Books Are Essential!

IMAGES
of America

PALM SPRINGS

ON THE COVER: Guests are under the ramada at the Palm Springs Hotel, the first hotel in the village, around 1898. (Courtesy of the Palm Springs Historical Society.)

IMAGES
of America

PALM SPRINGS

Moya Henderson and the
Palm Springs Historical Society

ARCADIA
PUBLISHING

Published by Arcadia Publishing
Charleston, South Carolina

Library of Congress Catalog Card Number: 2008931760

For all general information contact Arcadia Publishing at:
Telephone 843-853-2070
Fax 843-853-0044
E-mail sales@arcadiapublishing.com
For customer service and orders:
Toll-Free 1-888-313-2665

Visit us on the Internet at www.arcadiapublishing.com

To the early pioneers, who, through unbelievable hardships,
saw the potential of this desert town;
and to the board members, staff, and volunteers
of the Palm Springs Historical Society,
who labor to preserve the history of Palm Springs

CONTENTS

ACKNOWLEDGMENTS

When Melba Berry Bennett established the Palm Springs Historical Society, donations of photographs flooded in; among those were images from photographers Frank Bogert, Tony Burke, Bill Anderson, and Paul Popeseil. We thank them.

I am particularly grateful to the moral support and hours of work by staff and volunteers of the Palm Springs Historical Society: Cydronia Valdez, Eleanor Pohl, Sally McManus, Norma Cameron, Markie McManus, and, especially, director Jeri Vogelsang and research assistant Renee Brown. Also thanks for the experience and encouragement from my daughter-in-law Mary Alice Orcutt Henderson and the invaluable assistance of my daughter Harriet Harris.

All of the photographs in this book are from the archives of the Palm Springs Historical Society.

INTRODUCTION

This is a history of a village now known as Palm Springs, which grew up in a barren desert, and of those who changed it into a city known around the world. In a natural valley surrounded by mountains that formed a barrier for rainfall, and sitting beneath the Banning Pass between those mountains (Mount San Jacinto and Mount San Gorgonio), frequent windstorms were a problem. J. Smeaton Chase, author and Palm Springs pioneer, wrote in his book *Our Araby* that the area would always remain sparsely populated and then only by people who could appreciate and adapt to this special desert climate. Native Americans, specifically the Agua Caliente Band of Cahuilla Indians, had lived in the valley for at least 2,000 years before white men arrived, and had settled around a natural mineral hot springs and palm oasis located where the center of Palm Springs is today.

In 1884, Judge John Guthrie McCallum, his wife, and five children were the first non-Indian family to settle permanently in Palm Springs. McCallum brought his family here at the advice of his son Johnny's doctors, who said the dry air and warm climate could heal his tuberculosis. When they arrived, they found a handful of native Agua Caliente Cahuilla Indians and vast open expanses of land punctuated by emerald oases.

Judge McCallum bought up a section of land, Section 15, and made a living by selling crops from his orchard and selling off parcels. He brought water to the dry flatlands via a 19-mile flume from the Whitewater River north of Palm Springs to supplement the water received from the Indian irrigation flumes originating in the canyons of Mount San Jacinto. The Cahuillas had been growing crops before McCallum's arrival and helped him with planting fields of citrus fruit, figs, apples, corn, and alfalfa.

Soon Judge McCallum saw the need for a hotel to house the visitors and potential land buyers that the Southern Pacific Railroad, which completed its route through the Coachella Valley in 1883, would bring. He recruited his friend Dr. Welwood Murray from nearby Banning in 1893. Murray proceeded to build a group of cottages directly across from the Indian hot springs the Cahuilla's had formed their settlement around so that his guests could avail themselves of the healing waters. He called it the Palm Springs Hotel.

Now one of the two oldest remaining buildings in Palm Springs, the Cornelia White House began life as part of the city's first hotel. The structure now serves along with the McCallum Adobe as the headquarters for the Palm Springs Historical Society. In 1914, Cornelia White purchased the home, which Murray had built at the hotel for himself and his wife out of railroad ties from the failed Palmdale Railroad. White lived in it until her death in 1961, when she gave it to the city for use as a museum. Her sister Dr. Florilla White lived with Cornelia and was the village doctor during World War I. Another sister Isabel joined them and married J. Smeaton Chase, a naturalist and author of *Our Araby*.

Pioneers such as the McCallum family and the White sisters and other familiar names, including Lavinia Crocker, Harriet Cody, Nellie Coffman, and Carl Lykken, were looking for a better place to live and work. A great many were hoping to improve their health. All had a strong sense of

adventure. They rode their horses and donkeys, went hiking and camping, and farmed and ranched. For example, Cornelia White and her sister Dr. Florilla were cattle drivers. These pioneers also started businesses, some of which are still in operation today, like Casa Cody. They built homes, including the O'Donnell House, the Birge Estate (now the Ingleside Inn), and the Untermeyer home (now the Willows Bed and Breakfast). They hired quality architects like Richard Neutra, Rudolph Schindler, Albert Frey, John Porter Clark, Robson Chambers, William Cody, and E. Stewart Williams. One early example of the International Modern style in Palm Springs was designed by Albert Frey and his partner in New York at the time, A. Lawrence Kocher, in 1934. They were commissioned by J. J. Kocher, the first pharmacist in Palm Springs, who also happened to be Lawrence's brother, to build J. J.'s office, the Kocher-Samson Building, which still stands on North Palm Canyon Drive, although greatly altered.

After the pioneers came the movie studios. In the 1910s, matinee idol Rudolph Valentino was filming in the local sand dunes, and movie crews and actors were staying at the Desert Inn, established in 1909 by Nellie Coffman. William Powell, who ended up living in Las Palmas for more than 40 years, was filming in Palm Springs in 1925. The El Mirador Hotel, completed in 1928, hosted stars and the world's dignitaries and elite, and was the site of the city's first airport. Later, in the 1930s, the Racquet Club, the Ranch Club, and the Chi Chi nightclub were established. Stars and wealthy personages came, played, and stayed, building either permanent or second homes. Golf and tennis thrived against a backdrop of trail rides and rodeos. Moving into the 1950s, Palm Springs evolved into the leisure capital of the world, defined by a sleek, laid back, modern look, and thousands of cooling swimming pools combined with the old-world charm of original adobe, Ranch-style, and Spanish Colonial Revival–style structures that still exist today.

Judge McCallum's daughter Pearl McCallum McManus outlived all her siblings, remaining in Palm Springs until her death. She is greatly responsible for shaping Palm Springs into the charming blend of architectural styles it is today. She hired many fine architects to build hotels here, including, in 1923, Lloyd Wright, the son of Frank Lloyd Wright, to build the Oasis Hotel literally around her family home, the McCallum Adobe. She also hired Paul R. Williams to design the Tennis Club in the 1930s and Stewart Williams to build the Oasis Commercial Building in 1952. McManus even had the McCallum Adobe moved when she needed the space where it originally stood to build the Oasis Commercial Building. She had the home shifted to its present site on the Village Green Heritage Center in downtown Palm Springs to preserve it for future generations.

Today Palm Springs is a modern mecca in the desert known for its year-round lifestyle. Beautiful resorts, golf courses, homes, and shopping add to the desert mystique that locals and tourists alike come here to admire and treasure. Through careful development, first championed by pioneer Pearl McCallum McManus, Palm Springs has preserved the charm and natural beauty that brought the original settlers to this, *Our Araby*.

One

ORIGINAL PEOPLES

Situated near the bubbling hot springs from which came the name of Agua Caliente, and close to canyons with running streams, the area was an ideal spot for the Agua Caliente Band of Cahuilla Indians. Desert animals and plants were available for food, and native palms were used for homes and for weaving household items.

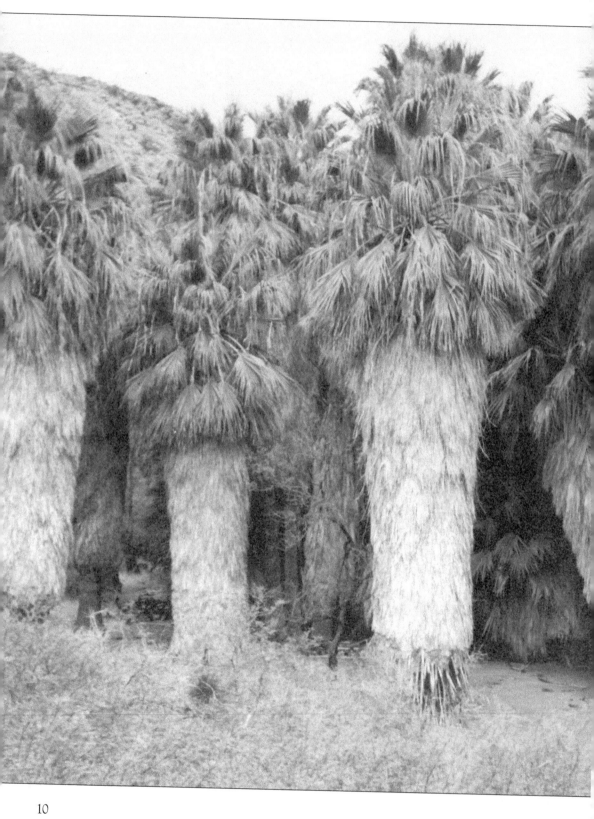

These *Washingtonia filifera* (palm trees) are the only palms native to the desert and stand in contrast to the stark rocky gorges and barren desert lands beyond. They are seen here in the beautiful Palm Canyon and are quite different than the green fan palms of Andreas Canyon. Palm and Andreas Canyons have the most and the second-most palm trees in the world. Centuries ago, ancestors of the Agua Caliente Cahuilla (pronounced "kaw-we-ah") Indians, settled in the Palm Springs area. They developed complex communities in the Palm, Murray, Andreas, Tahquitz, and Chino Canyons. Barely visible on the lower right-hand corner of this picture is a lone Indian sitting under a tree. This Indian land is open to visitors and is beautifully maintained by the Agua Caliente Tribe.

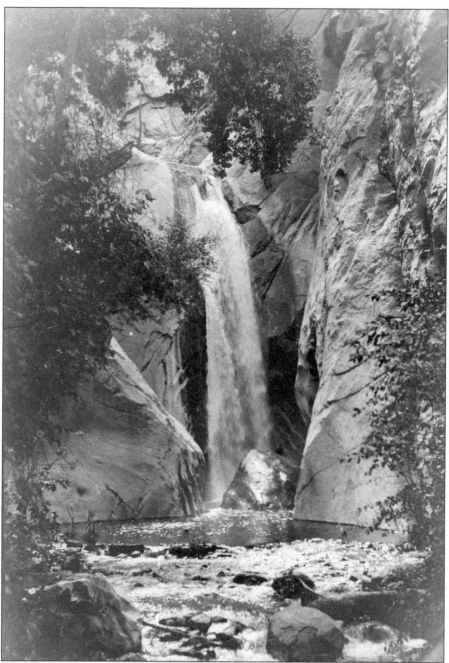

Dramatic Tahquitz Falls was, and is, the closest source of water to the settlement around the hot springs. It was also the only swimming hole for early settlers long before nearly every home had its own backyard pool. Tahquitz Falls is located in Tahquitz Canyon, one of the five Indian canyons. Indian legend has it that the evil spirit called "Tahquitz" inhabits this canyon. Natural disasters, hiking accidents, earthquakes, and rockslides are attributed to this spirit's wrath. Missing Indian maidens are suspected to be hidden within the caves of the canyon by this entity. It was here that *Lost Horizon*, directed by Frank Capra and starring Ronald Coleman, was filmed in 1937. Horses had to be airlifted by helicopter above the falls to shoot some of the scenes in the movie.

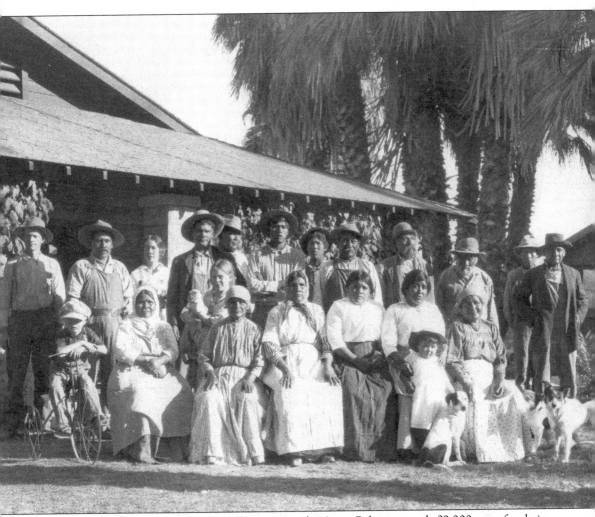

In 1876, the U.S. government deeded in trust to the Agua Caliente people 32,000 acres for their homeland. Some 6,700 acres lie within the Palm Springs city limits. First citizens of Palm Springs, members of the Agua Caliente tribe, were gathered in front of the house of Adrian Maxwell (second row, left), an Indian agent, farmer, and teacher. This picture, taken about 1914, includes not only Maxwell's family but also many names that are familiar to present-day residents as names of streets and canyons. Pictured from left to right are (first row) tribal members Augusta Patencio, Mrs. Pedro Chino, Anita Patencio Arenas, Emma Pete, Guadalupe Arenas, Electeria Brown Arenas, and Rose Belardo; (second row) Adrian Maxwell, Amado Miguel, Alice Maxwell (Adrian's wife), Lee Arenas, Gabe Costa, Clemente Segundo, Juan Segundo, Pedro Chino, Tom Segundo, Francisco Arenas, Joe Segundo, and William Marcus Belardo. Kermit Maxwell, the son of Alice and Adrian, is on the tricycle. Ellen, the Maxwells' daughter, is holding the dog behind Mrs. Pedro Chino. This is the spot where the hot springs erupted from the earth, where most of the Agua Caliente lived. A complete spa, including massages and facials, is now completely enclosed within the Spa Hotel.

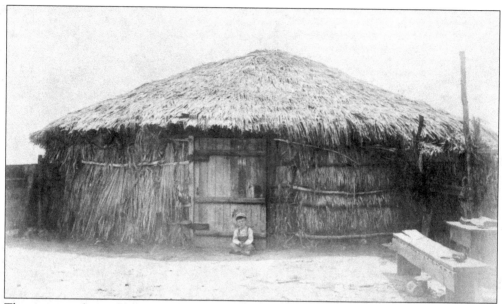

The ceremonial round house made of palm fronds was called "kishumnawut" by the Cahuillas. Here dances and important ceremonies were held. When the last "net" (headman of the village) died, the kishumnawut was burned down, and the "muirut" (sacred bundle and sacred beads) were buried with him. The round house was located at the corner of Calle El Segundo, a block from where Indian Canyon Drive stands today.

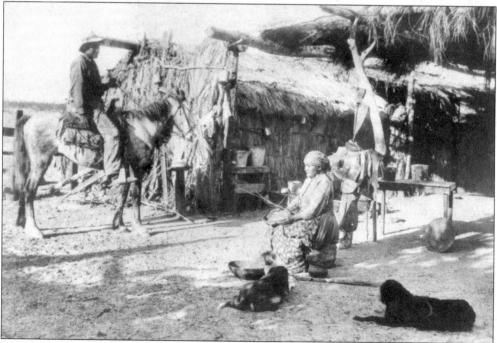

This Cahuilla home was called a "kish." They were simple homes of tree trunks and palm fronds, as well as other natural desert materials. When the weather was mild, cooking usually took place outdoors. Today people still prefer to cook and eat under the warm blue skies, and it's called a barbecue.

An important part of an Indian home was the ramada. Built of stout poles and covered with palm fronds, the ramada provided an outdoor living area and was open to catch the breeze. This was an idea often copied. Local schoolchildren experienced the benefits of a ramada when one was built at the Frances Stevens School.

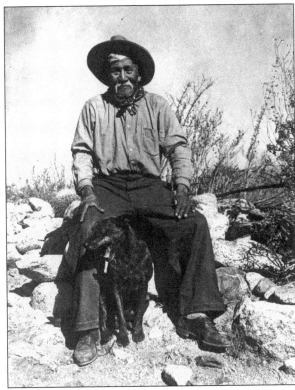

Pedro Chino was one of the most revered members of the tribe because he was a shaman (medicine man) with most unusual powers. It was believed he lived to be more than 100 years old. His home was directly north of the Indian baths. Chino Canyon, Chino Drive, and Vista Chino all bear his name.

Will Pablo is credited with introducing Judge John Guthrie McCallum in 1884 to the tiny oasis of Agua Caliente that was renamed Palm Springs. McCallum and his family were the first non-Indians to settle here. Will Pablo led the construction of McCallum's adobe home, which is now the headquarters for the Palm Springs Historical Society. Will Pablo was a member of the Morongo band of Mission Indians.

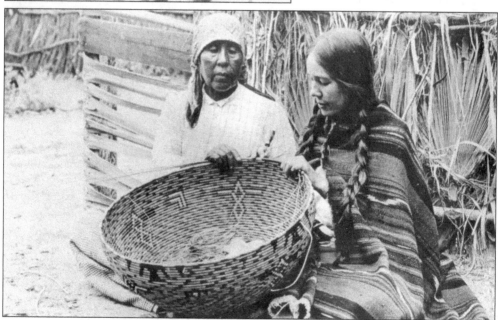

Dolores Patencio was famous for her beautifully designed Cahuilla baskets. In this c. 1912 photograph, she is giving a lesson in the intricate art of basketry to Alice Maxwell, wife of Indian agent Adrian Maxwell. These baskets had many uses and were so well made they could even hold water! Today Cahuilla baskets are considered extremely valuable. Fortunately, the Palm Springs Historical Society and the Agua Caliente Cultural Museum have an extensive collection.

Juan Patencio, patriarch of the largest tribal family, was born in 1856. He married Jane Augustine, for whom the Indian cemetery on Tahquitz Canyon Way is named. They were the parents of Anita Patencio Segundo, Alejo, Moreno, Albert, and Francisco. Pictured are Francisco and his wife, Dolores. Francisco, a ceremonial leader, was a teller of Indian legends. Patencio Road and Patencio Drive bear their name, and Alejo Road is named for Alejo Patencio.

Pictured are John Joseph Andreas (1874–1959) and his wife, Margaret Augustine Andreas (1874–1963), on their wedding day in 1910. John Joseph and his son Anthony Joseph (1911–1953) were both influential tribal leaders in Palm Springs. Andreas Canyon, Andreas Road, and Andreas Hills all bear their family name.

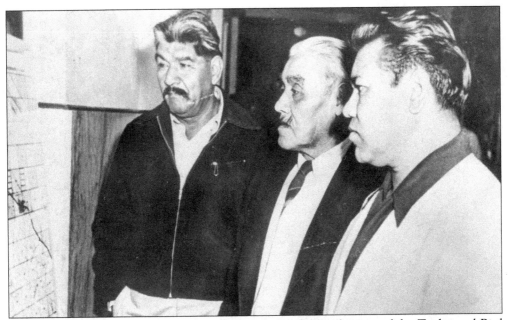

Anthony Joseph Andreas was the historian and also the head singer of the Traditional Bird Singers for the Agua Calientes. From left to right, tribal members Clemente Segundo, John Joseph Andreas, and his son Anthony Andreas Jr. are looking over a map of the reservation during the time of the 1949 Indian Allotment Act, which permitted the Indians to lease their own land.

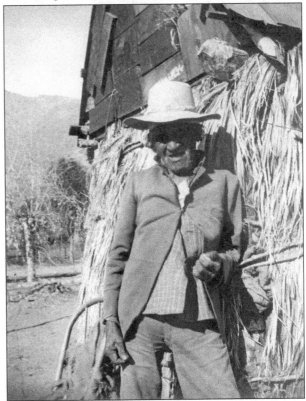

Marcus Belardo, born in 1882, is shown in front of his home in this photograph. He and his wife, Rosie, were members of the Agua Caliente Band of Cahuilla Indians that made their homes around the hot springs. Belardo Road and Calle Marcus were both named after the Belardo family.

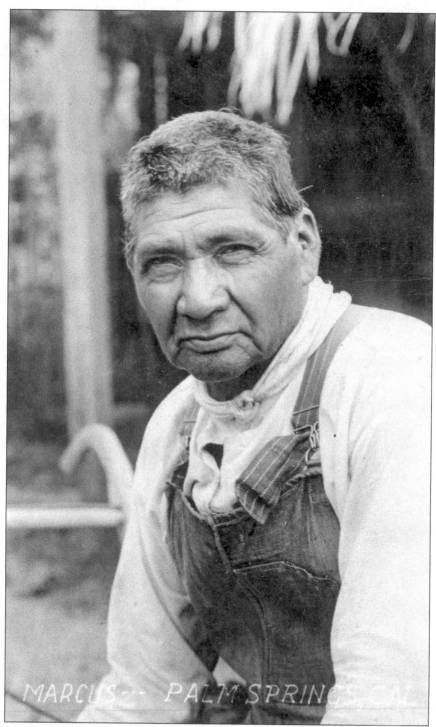

MARCUS -- PALM SPRINGS CAL

Willie Marcus Belardo was the son of Rosie and Marcus Belardo. His home, located south of the old bathhouse and spa, which had been built atop the hot springs on Indian Canyon Drive, was the place where families would get together to cook, eat, dance, and sometimes mourn their deceased.

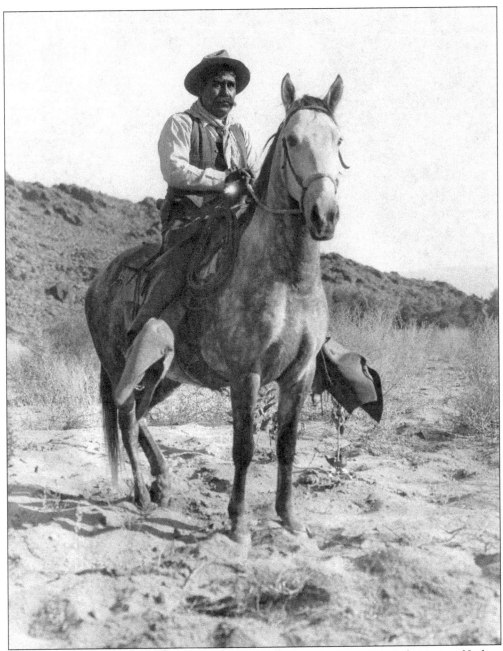

Miguel Saturnino was a rancher. He raised cattle and horses where the north corner of Indian Canyon Drive and Ramon Road are today. Saturnino was the chief supplier of meat for the Agua Calientes. Saturnino Road is named for his family. His brother, Guadalupe, was the father of Amado Miguel Saturnino, for whom Amado Road is named.

Tom Segundo was originally from the Los Coyotes Reservation. He married Anita Patencio, and they were the parents of Clemente (Clem), Juan (John), and Joe Segundo. Pictured here is Clemente Segundo. El Segundo Road, named for the Segundos, runs from Ramon Road to Alejo Road, which is within a section of the Agua Caliente Reservation.

Juan Bautista Lugo is seen here with his granddaughter Lena Lugo Martinez. Lugo, from the Cahuilla Reservation, was raised by the Franciscan priests and attended their school, where he learned how to speak Spanish. After leaving school at 18, he relocated to Anza and Hemet, where he worked as a sheepshearer. Lugo Road was named for the Lugo family.

Ramon Manuel was the stepson of Pedro Chino. He was also a political chief for the Agua Calientes. There were three types of chiefs: hereditary, ceremonial, and political. The tribe voted upon political leaders for a period of usually two years. This photograph of Ramon, standing at the Desert Inn entrance, was taken in 1928. One of the busiest streets in Palm Springs is named for Ramon Manuel.

This photograph is of Lee Arenas and his wife, Marian. It was Arenas who finally convinced the U.S. Supreme Court that members of the Indian band should have trust patents for their allotted lands. Congress voted to have this done in 1887, but the Department of the Interior never got around to issuing them. Finally, in 1947, the process of dividing up nearly 32,000 acres of reservation land began.

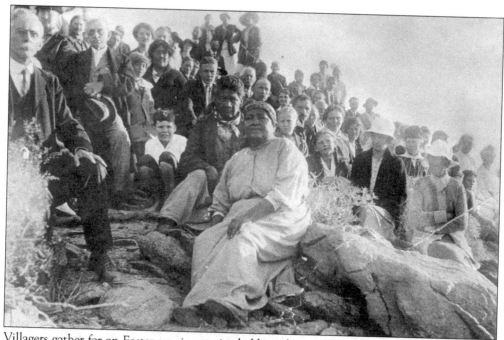

Villagers gather for an Easter sunrise service held on the mountainside behind the Desert Inn in 1917. This gathering was a first. On the left is the minister, Dr. John McPhee, who presided over what became an annual tradition. In the center foreground are Marcus and Rosie Belardo, members of the local band of Agua Caliente Indians.

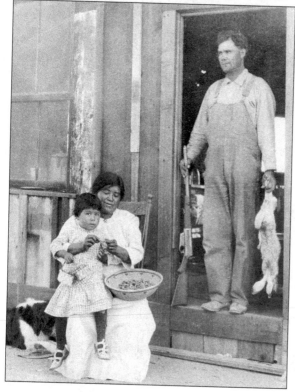

Francisco Arenas, born in 1836, was the father of Lee and Simon Arenas. Lee, who was born in 1878, was chosen to represent the Agua Caliente Indians in Washington, D.C. He participated in the epic courtroom decision that opened the way for accepting land allotments for tribal members. He is pictured here with his first wife, Lupe, and adopted daughter Della. Arenas Road was named for this family.

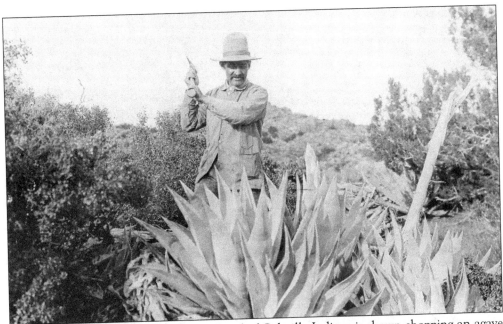

A member of the local Aqua Caliente Band of Cahuilla Indians is shown chopping an agave plant. Indians cooked and ate the leaves, stalk, and petals of this plant. A soak in warm water restored dried petals to their tender juiciness. Agave juice could be fermented to produce an alcoholic beverage. On the right side of the photograph is a creosote bush, which was often used for medicinal purposes.

Local tribe member Marcus Belardo (left) and Dr. Harry Coffman are attempting the thorny job of covering the large date bunches to protect them in their development from the strong rays of the sun on the grounds of the Desert Inn. As the date palm grows, this delicate job will have to be done using ladders.

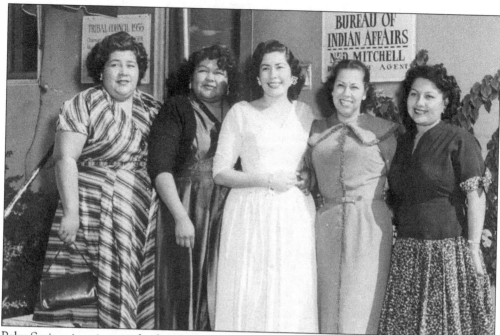

Palm Springs is unique in the fact that so many outstanding women pioneered and helped shape its destiny. In this photograph, the all-woman Agua Caliente Band of Cahuilla Indians Tribal Council has just put their signatures on the lease of Indian property to the developers of the Spa Hotel. Pictured from left to right are Laverne Miguel Saubel, Elizabeth Monk, Gloria Gillette, Chairman Vyola Ortner, and Eileen Miguel.

Richard Milanovich is the son of Laverne Miguel of the Agua Caliente Band of Cahuilla Indians and Steve Milanovich of Yugoslavian descent. He is presently the chairman of the Agua Caliente Tribal Council, having served on the council since 1977. He also serves on the Agua Caliente Cultural Museum's board of directors, the Agua Caliente Development Authority, and many other committees serving his tribe and the greater Palm Springs community.

Two

PIONEERS

This chapter is an introduction to the first white settlers and what brought them here. The word got out that the warm, dry climate was beneficial to those suffering from respiratory ailments, especially the dreaded tuberculosis.

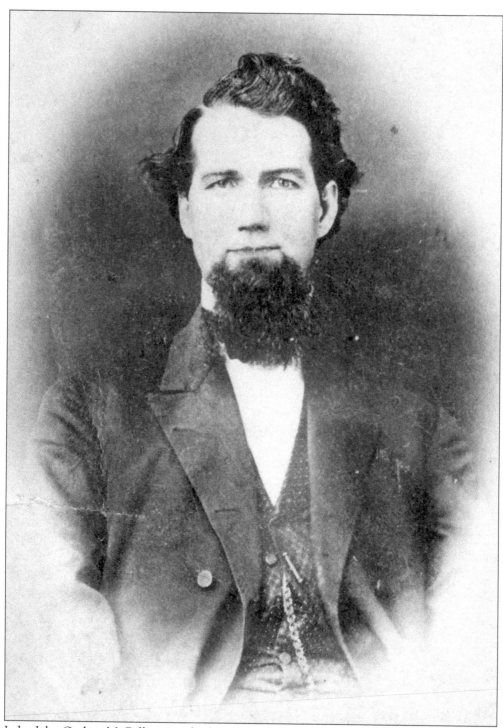

Judge John Guthrie McCallum was the first non-Indian to settle in Palm Springs. He was a state senator living in San Francisco when he was instructed to find a warmer climate for his tubercular son John. He went to Banning, where he met Will Pablo, an Indian who led him to the little Indian village in the desert, thereby changing the area forever.

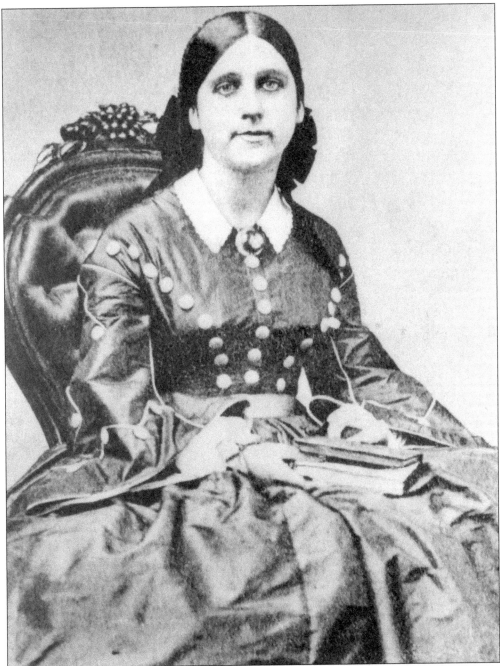

Records mention little concerning Emily Freeman McCallum, but she must have been a remarkable woman. A mother of six living children who was used to the role of a state senator's wife, she gave it all up for her son's health and came to the desert when there was not even a house to live in. The family camped out until their adobe home was completed.

Judge McCallum's hope for regaining Johnny's health became a reality. The hot, dry air did wonders for him, and he was able to help his father with ranch projects. However, a severe cold reopened his old tubercular scars, and Johnny died at the age of 26 at the Hotel del Coronado. The early growth of the village was due in great part to people seeking similar cures and finding them.

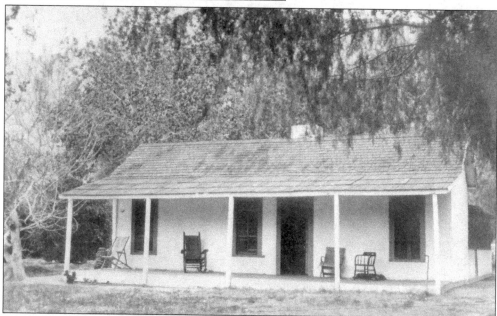

When Judge McCallum first brought his family, consisting of his wife, Emily, three sons, and two daughters, to the desert, they camped out under the trees. They watched the construction of their home, "Johnny's Ranch," as the Indians built it from the adobe brick they themselves made. The adobe eventually became part of the Oasis Hotel and was later moved to become the Palm Springs Historical Society on the Village Green Heritage Center.

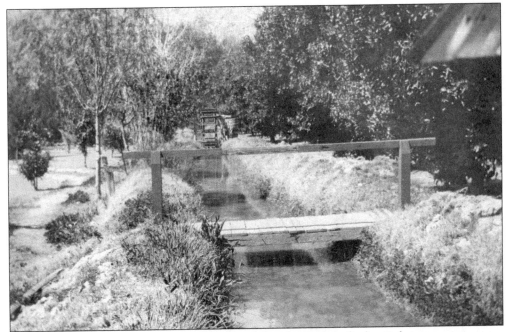

Judge McCallum contracted for 19 miles of rock-lined irrigation ditches to bring precious water to Palm Springs from Whitewater and Snow Creek for agriculture. The flume was completed in 1887. In this photograph, the water flows through his lush orange groves. The waterwheel filled water storage barrels.

Judge McCallum knew that in order for people to visit the Palm Springs area they must have a place to stay. He persuaded his friend Dr. Welwood Murray to lease some property from him. By 1893, the first Palm Springs Hotel was opened. Dr. Murray, a native of Scotland, was seldom seen without his tam-o-shanter and was considered an eccentric character. His wife (left) ran the hotel.

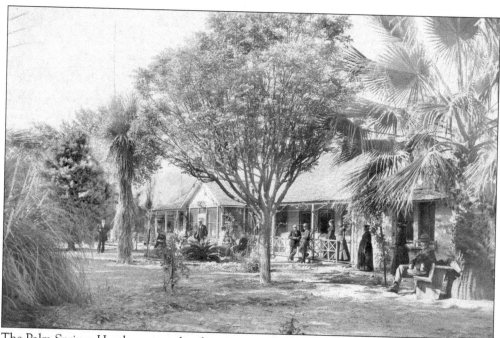

The Palm Springs Hotel was completed in 1893. It was built on land leased and later purchased from Judge McCallum as close to the Indian hot springs as possible, because Dr. Murray knew the healing powers of these waters would be a big draw for his guests. He leased the hot springs from the Indians for $100 a year. The bathhouse and dressing rooms were erected directly over the springs.

The rickety bathhouse built over the hot springs had two rooms, with the bigger covering a spring large enough to permit four people to stand together in the curative water. Silt-like mud at the bottom of the pool made it impossible to sink. Before the springs went commercial, children would play there and challenged one another to sink and stick to the bottom.

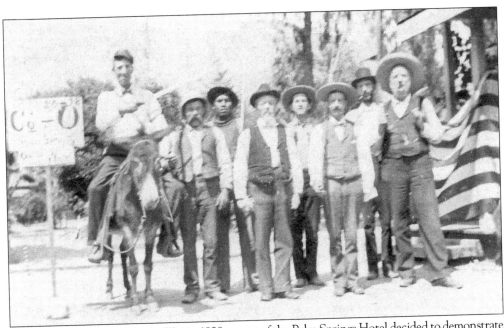

During the Spanish American War in 1898, guests of the Palm Springs Hotel decided to demonstrate their patriotism. They were provided with rifles from the hotel and locals. Pictured from left to right are Frank McQuoid, San Francisco; Andrew West, Los Angeles; a local unidentified Indian; L. Wagoner, San Jose; A. B. Trott and A. F. Jones, Brooklyn, New York; G. F. Casey, St. Louis, Missouri; and Col. William Roy, Nogales, Arizona.

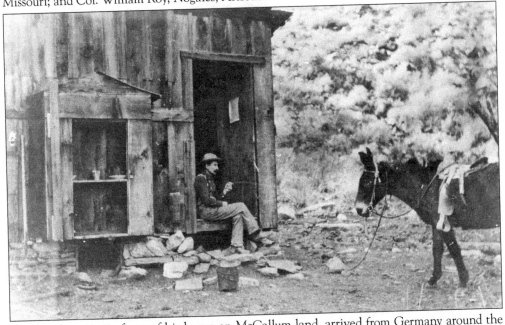

Carl Eytel, sitting in front of his house on McCallum land, arrived from Germany around the turn of the 20th century. His home, built from lumber salvaged from settlers' homes abandoned during the drought of 1894, was located near the site of today's Tennis Club. Eytel's love of the desert is captured in his hundreds of pen-and-ink sketches and paintings. His work did much to publicize Palm Springs.

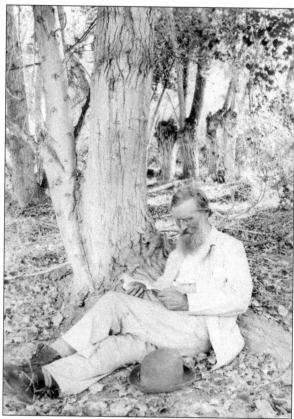

In the summer of 1905, famous naturalist John Muir brought his daughters Wanda and Helen to the desert because of Helen's ill health. They stayed at Welwood Murray's hotel. After three days in the 110 to 120 degree heat, the trio moved to beautiful Andreas Canyon, where they stayed for the remainder of their two-week visit. John is pictured here sitting under a cottonwood tree in lush Andreas Canyon.

In 1902, businessman David Manley Blanchard (center) owned the first general store, grocery, and post office. He was also the local barber and ran a four-room hotel on Main Street. Burros were often used for transportation. This was especially convenient because semi-wild burros roamed the canyons around Palm Springs.

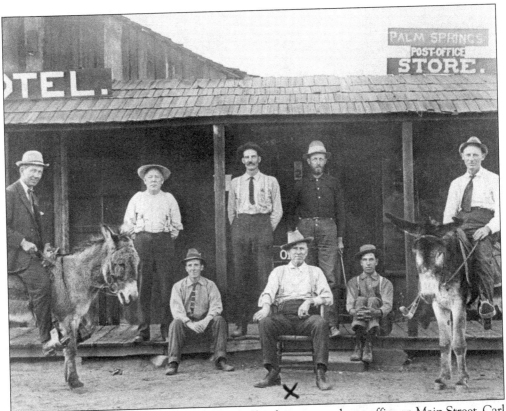

D. M. Blanchard and his friends pose in front of his first store and post office on Main Street. Carl Lykken and J. H. Bartlett later purchased the properties. When Lykken became sole owner, he enlarged the store into the Palm Springs Department and Hardware store. This building stands today in the heart of downtown Palm Springs.

This 1907 picture is of Welwood Murray (center left, with arm raised) greeting friends on Main Street, now known as Palm Canyon Drive. It was taken in the center of the Village where today three lanes of traffic, often bumper to bumper, are an everyday occurrence. One of Dr. Murray's most important guests, as far as Palm Springs is concerned, was Nellie Coffman.

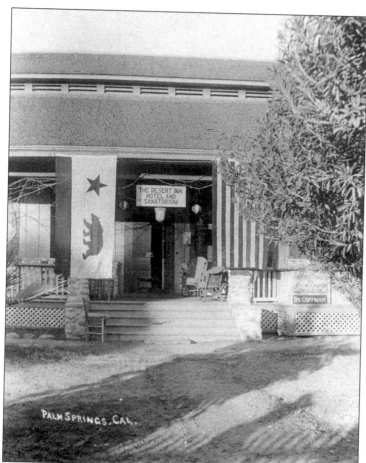

After visiting Dr. Murray, Nellie Coffman returned to the desert with her husband and their two sons. After buying Lavina Crocker's Tent Homes for Invalids and additional adjoining property, they opened Dr. Harry Coffman's Desert Inn Hotel and Sanatorium in 1909.

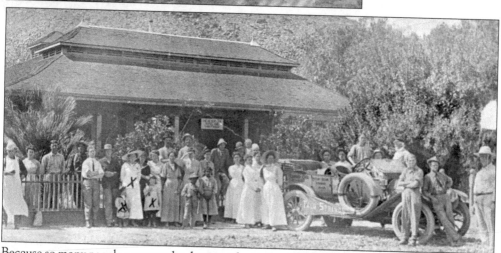

Because so many people came to the desert with respiratory diseases, Dr. Coffman wanted a place to treat them, while Nellie was looking into the future anticipated tourism. She won, and they parted ways. She then changed the name to the Desert Inn. In this 1912 photograph, taken in front of the hotel, Dr. Coffman is on the far right, and William Wrigley, of chewing gum fame, is sitting up in the car.

Most of the original structures at the sanatorium were tent houses. These proved appropriate to a desert climate that had not as yet discovered air-conditioning. The inn was solely for people suffering from asthma, arthritis, and similar ailments. While no mention of tuberculosis was ever made, many of Nellie's guests were listed as having "bronchitis" upon registration.

The front yard of the Desert Inn and Sanatorium was the designated voting site. Carl Eytel is the gentleman sitting at the far right. Zaddie Bunker is seated at the center table. Although women were in charge of the proceedings and did the work, they probably did not vote. That right was not given to them until 1921.

To Nellie Coffman goes much of the credit for taking Palm Springs from a quiet health resort to a major tourist destination. When a road was paved into the village, she recognized the potential of Palm Springs as more than a place for people who were ill. Her husband did not share her vision for a first-class hotel. When Dr. Coffman moved to Thermal to open another sanatorium, Nellie and her sons George Roberson (a son from a previous marriage) and Earl Coffman acquired the Desert Inn. Their new brochure was specific: "no invalids." In no time, the Desert Inn's roster contained names of famous people from all over the world. Mrs. Coffman was a most generous and giving person. No one in town went hungry or unclothed if she knew about it. The doors of the inn were always open to locals for school parties and charitable functions. She was a member of the Desert School Board, and the Nellie N. Coffman Middle School is named in her honor.

Dr. Florilla White was a familiar figure in her spotless puttees and white hat, with her collies by her side. She brought her sister Cornelia here in 1913, and together they purchased the Palm Springs Hotel property from Dr. Murray. Their sister Isabel joined them in 1916 and married J. Smeaton Chase two years later. J. Smeaton Chase was not only a prolific photographer but also a well-known author.

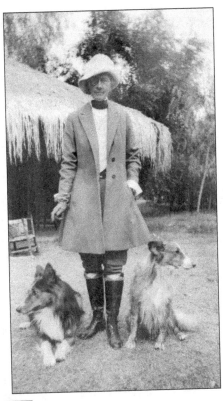

Cornelia White was an adventurous woman. She grew up in New York, taught at the University of North Dakota, and along with her sister, Dr. Florilla White, was enticed to join a group of Americans seeking to start a colony in Mexico. However, a restless Mexican government threw the Americans out three times. Florilla, fearing for her sister's health, talked her into coming to Palm Springs.

Like her sister Florilla, Cornelia loved the desert. These women hiked the hills, went on cattle drives, were involved in local politics and community improvements, and generally made the most of their lives here. In 1947, Miss Cornelia, as she was always called, donated property for the building of the Palm Springs Desert Museum.

Cornelia White's house, made of railroad ties, is the second oldest house in Palm Springs still standing. It has been moved twice, first from the grounds of the former Welwood Murray Hotel complex to a site across the street on Indian Avenue and Tahquitz Way, then once again to the Village Green to become part of the Palm Springs Historical Society's museum.

Carl Lykken, a student of Cornelia White's in North Dakota, had engineering and surveying skills. He was invited to join Cornelia, Florilla, and several other Americans in their ill-advised colony in Mexico. After his eviction from Mexico, with nowhere else to go, he followed Cornelia to Palm Springs. Becoming a businessman, he took a small store and built it into a combination dry-goods and hardware store and post office.

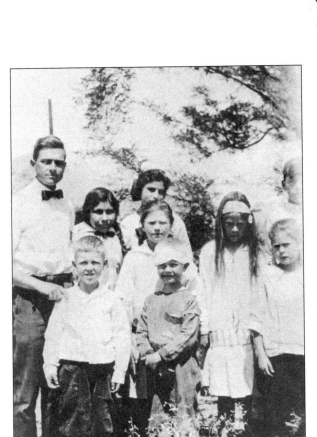

Pictured are teacher Dr. Edmund Jaeger and his students from the 1915–1916 school year. From left to right are (first row) Jackie Robinson, Sallie Stevens, Kermit Maxwell, Ellen Maxwell, and ? Kovass (second row) Edmund Jaeger, Annie Pierce, Stella Block, Clarence Block (half visible). Edmund Jaeger was a renowned botanist on desert plants, and his books are still in use today.

After the disastrous 11-year-long drought that began in 1893 wiped out his orchards, a discouraged Judge McCallum passed away in 1897. However, his daughter Pearl made Palm Springs her permanent home. Always remembering her father's dream, she jealously guarded the development of any property she owned so that it would be a credit to the growing town.

In 1914, Pearl McCallum met and married Austin McManus. They are pictured here on horseback watching the development of the bridge over Tahquitz Creek at Highway 111. This bridge allowed the village to stay connected even in times of flood. While alive and even after her death, Pearl donated a fortune to charities, colleges, and museums.

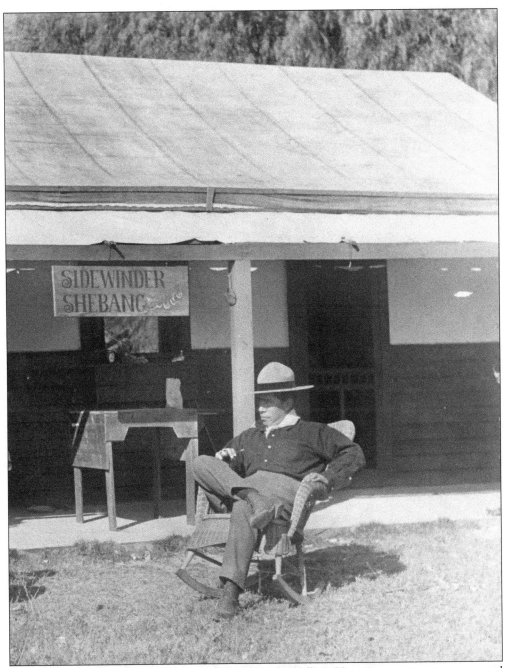

Jimmy Swinnerton, living in New York and working for William Hearst as a cartoonist, contracted tuberculosis. Hearst sent him West, and he decided to stay. He moved into a tent house known as the Sidewinder Shebang at the Desert Inn. Here he received national acclaim as a desert artist. In spite of being given a year to live at the age of 21, he died in Palm Springs at the age of 99.

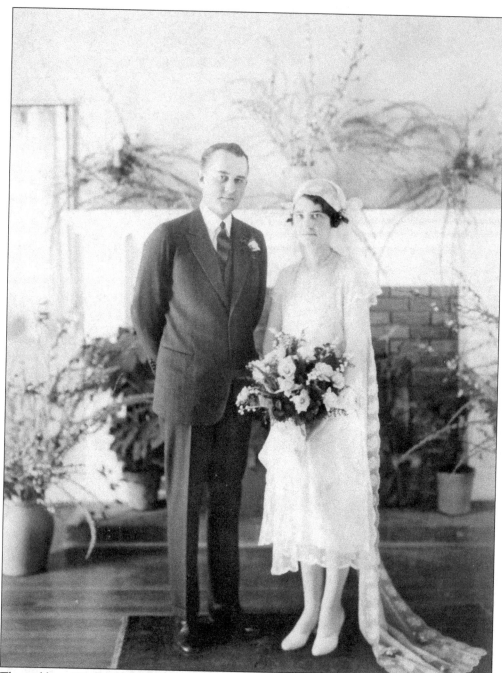

The wedding of Phillip Boyd and Dorothy Marmon was held in the home of Nellie Coffman in 1926. Twelve years later, Phillip was elected to be the first mayor when Palm Springs was incorporated in 1938. The Boyds are believed to be the first non-Indians to be married in Palm Springs.

Stephen Willard, another early artist, is heading out to the desert showing of wildflowers. Willard's camera shop was on Palm Canyon Drive. He became famous for his hand-tinted desert scenes of postcards and for his beautiful enlargements. It was hard to recognize them as photographs and not paintings. The Willard home is now the Moorten Botanical Gardens on South Palm Canyon Drive.

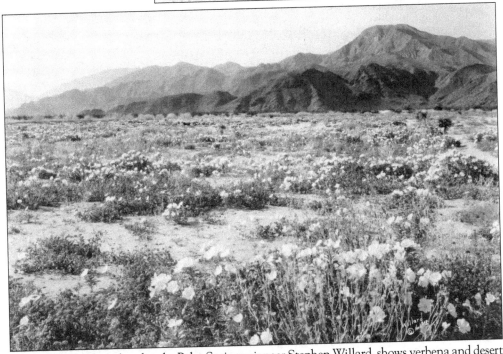

This 1920s photograph, taken by Palm Springs pioneer Stephen Willard, shows verbena and desert primrose and is a view of the desert floor before the development of multiple homes and golf courses. An artist and photographer, Willard tinted his photographs to make beautiful postcards.

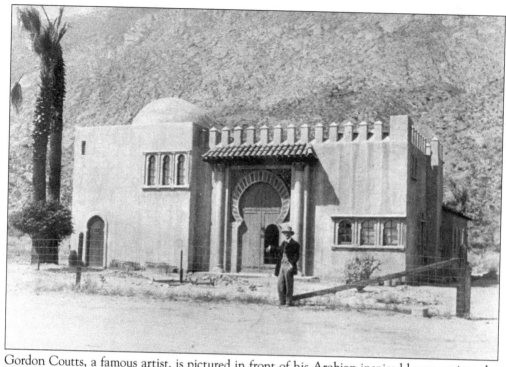

Gordon Coutts, a famous artist, is pictured in front of his Arabian-inspired home against the mountain. His most famous painting was a nude. His wife was his model. Both their daughters, Jeane and Mary, attended Palm Springs schools. Today their home has become a special bed-and-breakfast called Korakia Pensione.

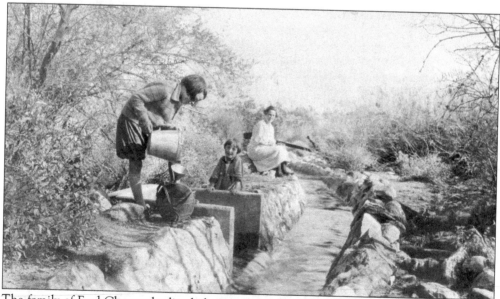

The family of Fred Clatworthy lived close to the mountain at the west end of Ramon Road. Barbara, Helen, and their mother, Mabel, are seen in this photograph drawing water from the Tahquitz flume. Fred was a world-famous photographer often featured in *National Geographic*. Whether this photograph was a magazine pose or was taken while the family was simply meeting the need for water at their home, only Fred knows for sure.

Adolph Demuth was a carpenter. Little else is known about him. He did not seem to have a family. He lived in and owned a small court in the 300 block of North Palm Canyon Drive. It was later purchased by the Herbert Carpenters as an annex to their Sunshine Court. Upon his death, Demuth left the city $30,000, which was instrumental in creating Demuth Park.

Early pioneer Lawrence Crossley came to Palm Springs from Louisiana in the 1920s. Working for P. T. Stevens, he built the El Mirador golf course and was the operations manager, or "zanjero," of the Whitewater Mutual Water Company. Using his savings, he bought parcels of land, including one on Ramon Road and another on the east side of today's city golf course known as the Crossley Tract. Crossley Road is named after this well-liked gentleman.

49

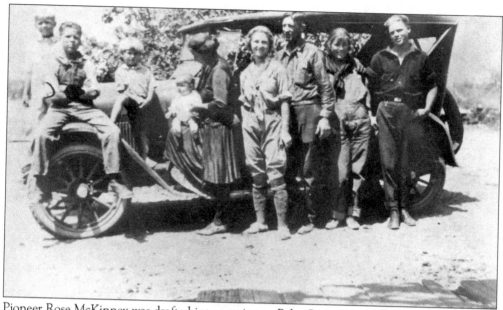

Pioneer Rose McKinney was drafted into coming to Palm Springs in 1915. Her four school-age children were badly needed to swell existing numbers so that the county would authorize the hiring of a schoolteacher. Former city council member Ted McKinney was the first white child born in Palm Springs.

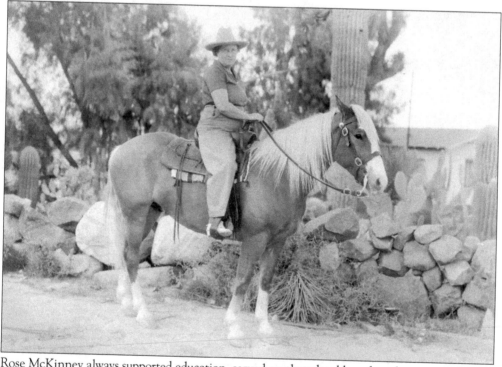

Rose McKinney always supported education, served on the school board, and encouraged many youngsters to continue their education with the Oliver and Rose McKinney Scholarship. She is pictured on her horse in front of the McKinney Court on South Palm Canyon Drive, which was the first commercial cactus garden in this area.

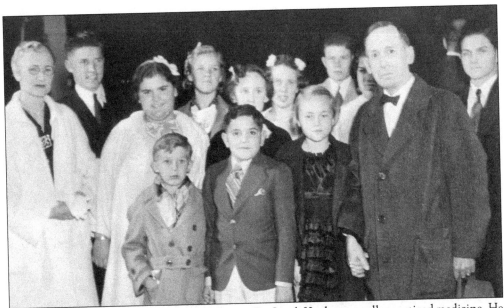

While other doctors came to visit Palm Springs, Dr. Jacob Kocher actually practiced medicine. He is shown here at the "Stork Party" for babies he delivered, many of whom still live in Palm Springs. From left to right are (first row) Bobby Bell, Nick Mustascio, Helen Louise Williams (holding Dr. Kocher's hand), and Dr. Kocher; (second row) Reta Kocher, Ted McKinney, Carmella Mutascio, Barbara McKinney, Beatrice Willard, Elizabeth Coffman, Owen Coffman, Vyola Hatchitt, and Frankie Bellue.

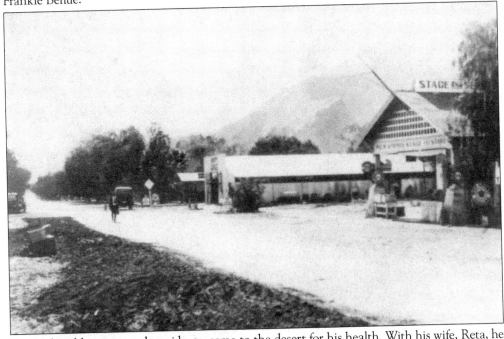

Dr. Kocher, like many early residents, came to the desert for his health. With his wife, Reta, he ran the local drug and apothecary shop. His car is parked in front of his office, located on Palm Canyon Drive. Also visible are the grocery store, stage stop, and the Hotel La Palma. This picture also captures one of Palm Springs rare snow days on Main Street.

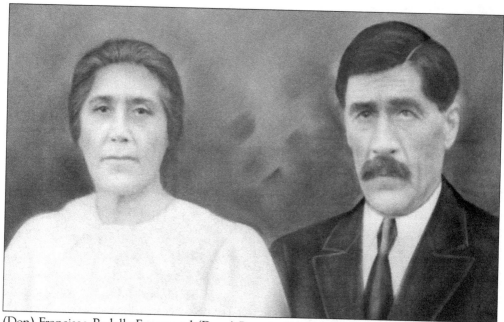

(Don) Francisco Bedolla Fontes and (Dona) Rosario Dominguez Fontes came to live in Palm Springs in 1924. They raised seven children, plus numerous grandchildren and great-grandchildren. One of Francisco's contributions to Palm Springs is the magnificent stone wall he helped build on the mountainside above the O'Donnell Golf Course. Francisco was also responsible for laying the first pavement on Palm Canyon Drive.

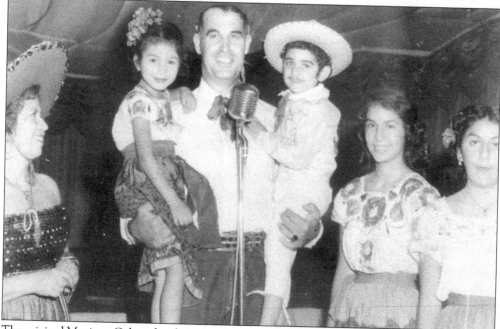

The original Mexican Colony families settled in the Village of Palm Springs in the early 1920s after fleeing to the United States from the revolutions in Mexico. They have always been a colorful and vibrant part of the community's history. In one of their celebrations, Frank Bogert is introducing Rafaela Marmolejo Valdez, Cydonia Valdez, Omar Valdez, Maria, and Rafaela Marmolejo.

Melba and Frank Bennett came to the village in 1929. While busy managing the Deep Well Guest Ranch, Melba found time to serve on the library board, the school board, and the Riverside County Republican Central Committee. She was the founder of the garden club and the historical society. Melba was the originator of the "Palm Springs Hat." She authored the biography of Robinson Jeffers entitled *The Stone Masons of Tor House*. She also organized the Village Insanities for Desert Circus.

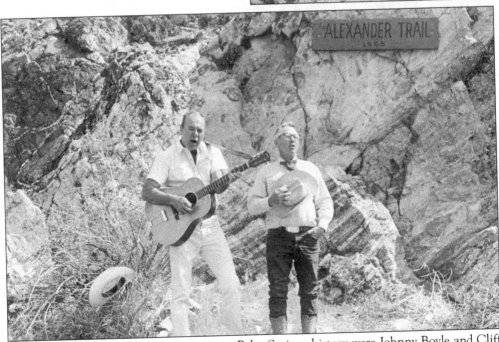

Two of the most famous cowboy singers in Palm Springs history were Johnny Boyle and Cliff Campbell. No desert breakfast horseback ride or steak ride was complete without one or the other serenading the group around the campfire. Here Johnny has thrown his hat in the brush as he strums his guitar. Johnny usually sang with his beautiful wife, Tani.

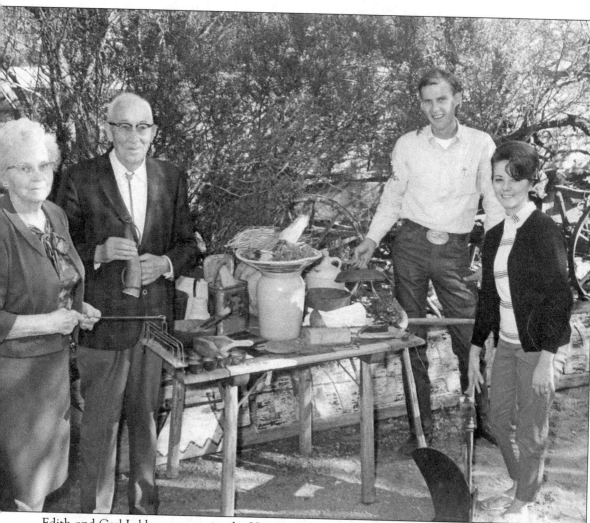

Edith and Carl Lykken never missed a Historical Society Founders' Day Picnic. Carl Lykken arrived in Palm Springs in 1913 together with Florilla and Cornelia White after their sojourn in Mexico. He almost immediately demonstrated his financial courage by opening the city's first general store. His additional firsts in Palm Springs include the first telephone, the first telegraph, the first grocery store, and the first home with central heating. He also helped found the Palm Springs Rotary Club, the city's library board, the Polo Club, the Desert Riders, and the city's first police and fire protection districts. The Lykkens are shown here with Clark Moorten and his wife, Linda, examining memorabilia from an earlier era. This Paul Pospesil picture was taken at the Moorten Botanical Garden owned by Clark's parents, Patricia and Cactus Slim Moorten. The Moorten Botanical Garden is still in business today, and it is a popular tourist attraction and spot for local weddings and private parties.

Three

TRANSPORTATION

This chapter explains how pioneers traveled through the desert where trails existed rather than paved roads. The horse was king during this time. The sandy ground was difficult for four-wheeled carriages to traverse, but a horse could get his rider anywhere he wanted to go.

More than a decade before the arrival of the Southern Pacific Railway, stage routes were planned from Yuma through the San Gorgonio Pass. This stage station was built to handle that traffic. Various stagecoaches and freight lines crossed the desert. However, it was Big Bill Bradshaw who chose the Palm Springs oasis as a stopping point for his stage, which ran from Los Angeles to the gold fields of Arizona.

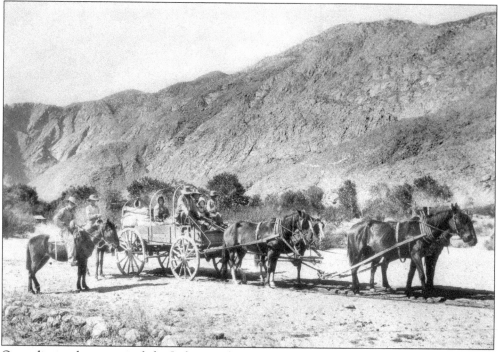

Once dirt roads augmented the Indian trails, wagons, such as the one pictured here, brought supplies into town from the train stop 10 miles out at Garnet or all the way down from San Bernardino. This 1898 picture was taken at what is now the corner of Palm Canyon Drive and Tahquitz Canyon Way.

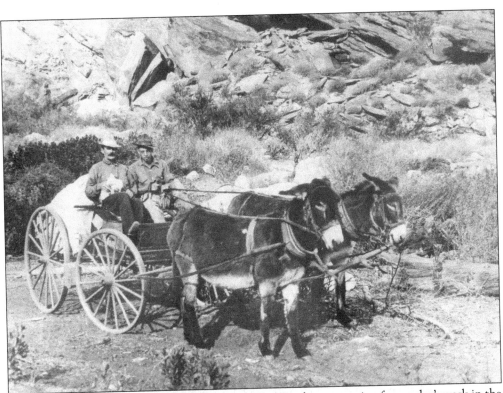

Here photographer W. W. Lockwood and artist Carl Eytel are returning from a day's work in the desert. Many of Lockwood's photographs were printed from old wet plates. The Palm Springs Historical Society Museum is fortunate to have many of Eytel's now valuable sketches and paintings in its collection.

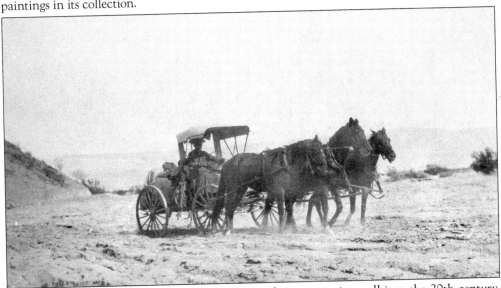

The horse and buggy continued to be the practical transportation well into the 20th century. Four-legged power could cope with sand and rocks much better than four narrow tires. Here, in 1904, Pearl McCallum is driving her three-horse team on the three-hour trip to Banning through the deep sand around Windy Point on Highway 111.

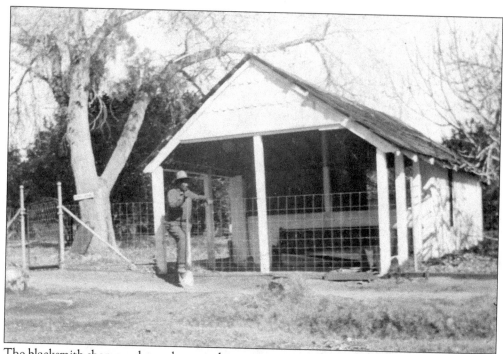

The blacksmith shop may have also served as a stage station. This 1914 photograph was taken at what is now the 100 block of North Palm Canyon Drive. While cars were starting to make their appearance, there was still plenty of work for a good blacksmith.

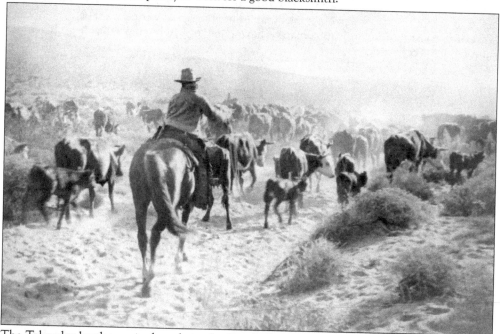

The Talmadge brothers raised cattle in the Coachella Valley and are shown here driving them to Big Bear Valley. This was a frequent event, and Cornelia and Florilla White often joined the brothers on their cattle drives. This drive was in 1914, and Cornelia and Florilla can be seen from the rear on horseback.

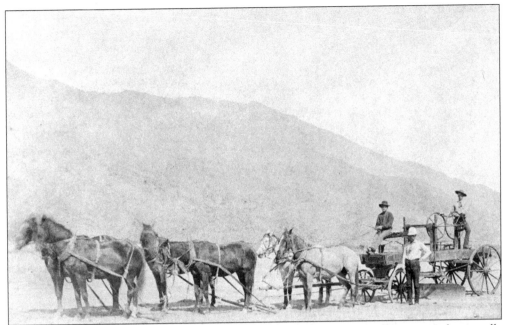

Keeping the roads passable into the village was a continual chore because of blowing sand, especially out at Windy Point. This is the road maintenance equipment required for the job. The scraper must have been solid iron, because it took six horses and three men to work the rig.

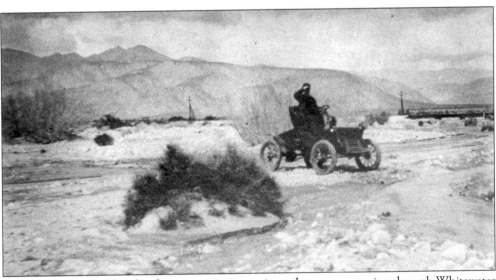

Early resident D. M. Blanchard is attempting to navigate the stream running through Whitewater Wash in his horseless carriage. The road into Palm Springs, now known as Highway 111, was a one-lane, sand and oiled surface as late as 1923. Not until the advent of macadam roads was it deemed advisable to drive to the desert.

Zaddie, Ed, and daughter Frances Bunker came to the village in 1913 and opened the first garage. Zaddie was the first woman in California to obtain a chauffeur's license, and she used it to transport visitors to and from the train. In later years, this remarkable woman received her pilot's license and became famous as the "Flying Grandmother."

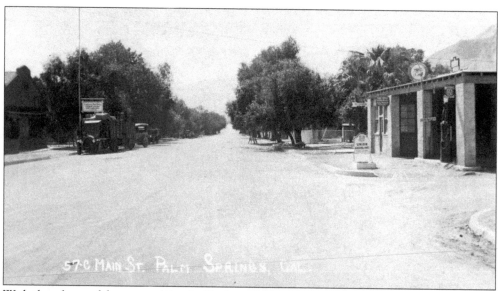

With the advent of the automobile, the blacksmith shop was replaced by the service station. The Desert Inn Garage also housed the Buick dealership. J. Smeaton Chase wrote many years ago that the desert would only be frequented by the few that appreciated its varying moods and harsh climate. He certainly never envisioned modern freeways and air-conditioning.

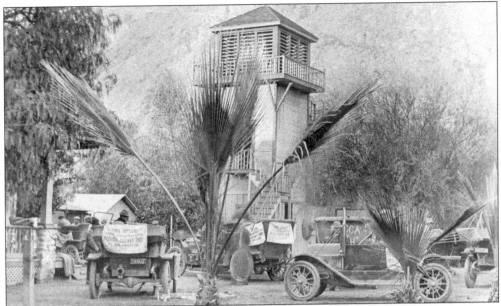

Now that there were roads, such as they were, enterprising entrepreneurs decided to advertise the route from Yuma through the Coachella Valley and the San Gorgonio Pass as the logical way to Los Angeles from the east. Here, around 1915, twenty-two carloads of "Route Boosters" stop overnight at the Desert Inn. In spite of advertisers' best efforts, Route 66 seemed to have greater appeal.

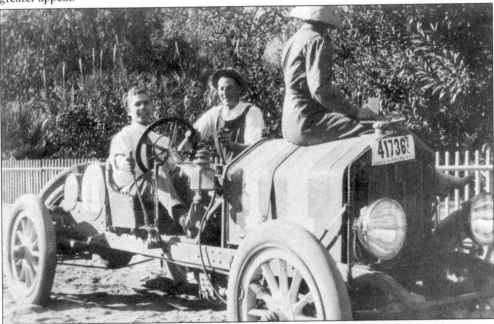

This sporty trio, around 1910, getting ready to race down Main Street, from left to right consists of Earl Coffman, George Roberson, and Cornelia White. This picture was snapped in front of the Desert Inn. The boys were planning to use the car in a race to promote the Coachella Valley and the San Gorgonio Road to Los Angeles. The license plate reads, "Loaned by the National Motor Car Company."

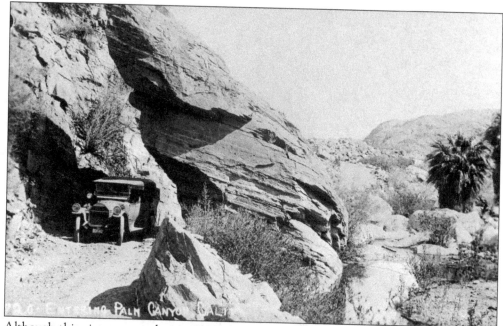

Although this picture was taken in 1922, this formidable solid rock arch still guards the road into Palm Canyon. Even today, space is limited to one car, so traffic can be slow for tourists on a busy weekend. This Stephen Willard photograph was taken on one of his many trips into the canyons.

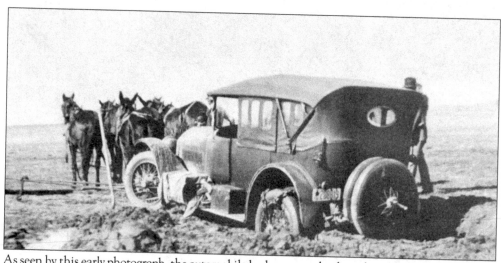

As seen by this early photograph, the automobile had not completely replaced the horse. Although Main Street had been paved by 1915, the side roads had not. Even with chains on the tires, this car was no match for the desert sand. The same is true today, and the smart motorist will do well to stay on the paved highway.

A new Southern Pacific station was built about 10 miles north and west of town to bring in the rich and famous who were discovering Palm Springs. Hotels sprang up to accommodate the visitors. Places such as the Oasis, the Desert Inn, and the El Mirador all had buses to shuttle their guests. Southern Pacific promoted the city with posters and campaigns.

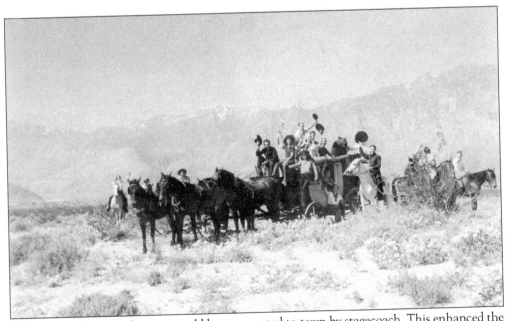

Early travelers arriving by train could be transported to town by stagecoach. This enhanced the village's Western character. The stagecoaches were also used by local stables, such as this one operated by Trav Rogers, to pick up tourists at their hotels and transport them out to the desert for breakfast rides and moonlight barbecues.

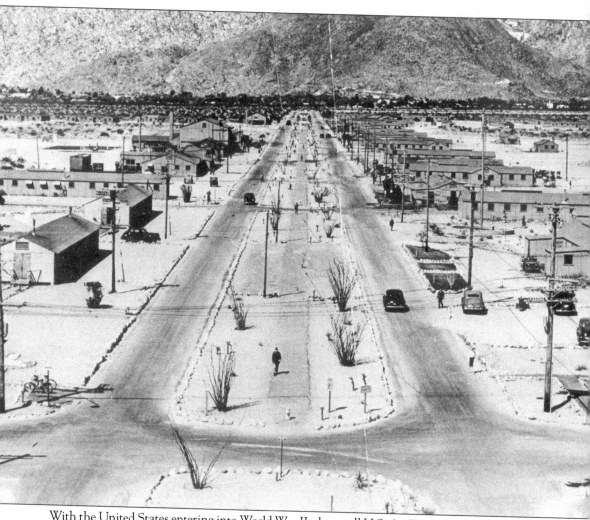

With the United States entering into World War II, the small U.S. Air Force Ferrying Command at Long Beach came to the desert and replaced the old Palm Springs Airport with a new facility on the east side of Palm Springs. At that time, there were only dirt roads from Indian Avenue to Sunrise Way and Ramon Road to Alejo Road. The city built a new road from the center of town to the new airport on land owned by Pearl McManus. She gave the right-of-way to the city for the road, and in exchange, it was named McCallum Way in honor of her father. Barracks, a fire station, a post exchange, operations, warehouses, a recreation room, and hangars were built. Because this field was protected from fog and rain, it was ideal for ferrying supplies and aircraft coast to coast. After the war, the barracks were sold and individually moved to locations throughout the desert. The city took over the facilities and developed the present airport. This enabled Palm Springs to go from a Hollywood playground to an international destination.

American Airlines *Flagship Palm Springs* stopped to pick up a load of "First Day Covers" that were stamped and mailed from the village. It was later discovered that the flight was not authorized to carry airmail from the desert. Many locals are still in possession of those envelopes. It seemed important enough at the time to acquire three pretty models to pose for the occasion.

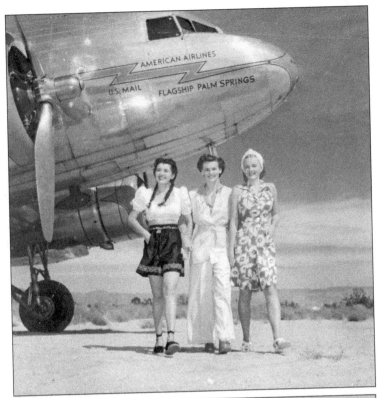

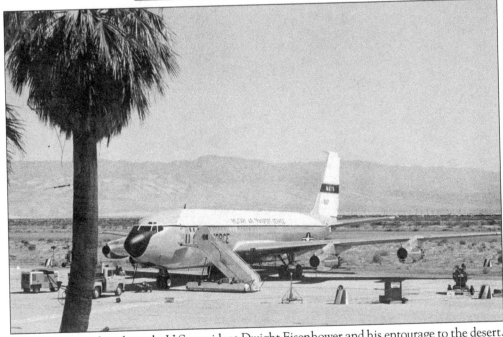

In 1960, this airplane brought U.S. president Dwight Eisenhower and his entourage to the desert. Probably more U.S. presidents have landed at this airstrip than any similar sized city in the country. After his retirement, President Eisenhower and his wife, Mamie, moved to the desert and became permanent residents.

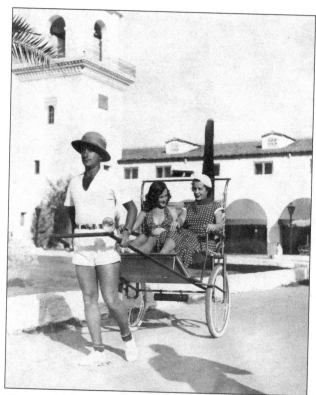

Here is an answer to the gasoline crunch. In the early 1930s, rickshaws became a popular means of conveyance. Pictured here, with the famous El Mirador tower as the background, are glamorous Paulette Goddard and her mother heading downtown to shop. The handsome Glen Martin provides muscle power.

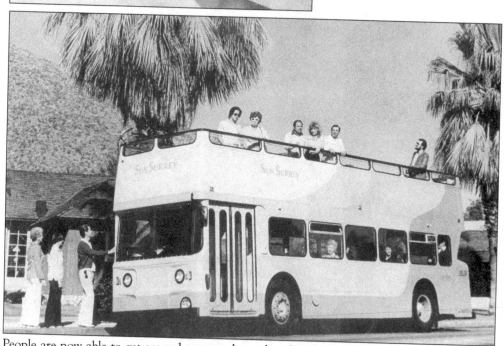

People are now able to get around town and to other Coachella Valley cities on the SunLine buses. An added attraction for tourists are the many jeep and trolley tours, which go to the Indian canyons, surrounding points of interest, and historic sites. This double-decker Sun Surrey is picking up passengers at the Village Green, home of the Palm Springs Historical Society.

Four

EARLY COMMUNITY

Palm Springs has experienced the needs of a growing community. Judge McCallum persuaded his friend Welwood Murray to come down from Banning to establish the first hotel. Advertising appeared in Los Angeles touting this as a wonderful climate for agriculture. A growing community needed stores, schools, and, eventually, churches. The first teacher had to have enough of her own children to augment the number of students required by Riverside County.

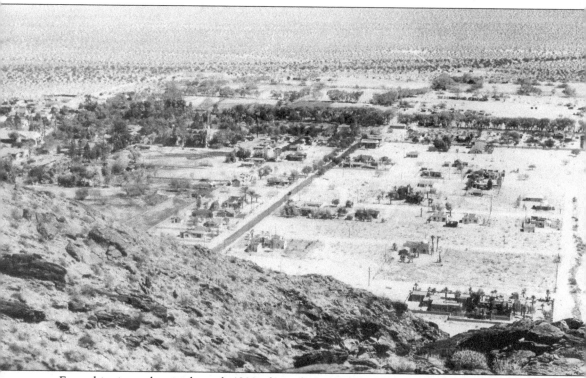

From this view, taken in the early 1920s above the present-day Tennis Club, it is obvious why the town was always referred to as "the Village." The tree-lined street near the top of the photograph is Indian Avenue, with Palm Canyon Drive paralleling it. The dark street cutting through the center of the picture is Arenas Road. The open space among the trees in the left part of the picture was the Desert Inn Mashie Course. Closest to the mountain and on the right of Arenas is the McManus house. Right of it, with its dome barely visible, is the home built by artist Gordon Coutts. It still stands there today, as does the Bill Rice home in the right-hand corner of the view. Obviously, there was still plenty of real estate for sale. Today few lots in this location are vacant.

Main Street, now called Palm Canyon Drive, is shaping up. In this photograph, the Ramona Hotel appears next to the La Palma Hotel. A growth in hotels shows that the word was getting out about this little desert oasis. Harry Mutascio would take advantage of this popular site and build his pool hall across the street from the La Palma Hotel.

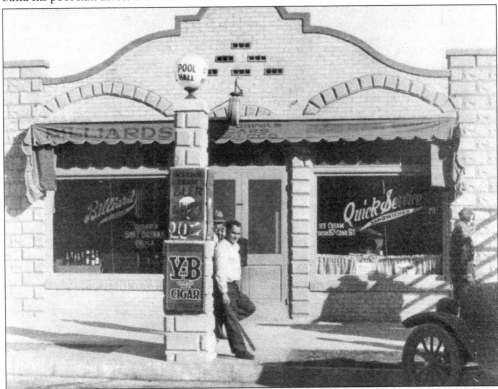

Harry Mutascio is shown in front of his pool hall and lunch counter. Arriving in Palm Springs from Genoa, Italy, in 1922, Harry saved enough money to buy six pool tables for $5 each. He repaired them, built the pool hall, and charged 5¢ per game. His wife, Josephine's, great cooking prompted him to add a restaurant, which they successfully ran until 1945. Later sold to Irwin "Rudy" Rubenstein, it became Ruby's Dunes.

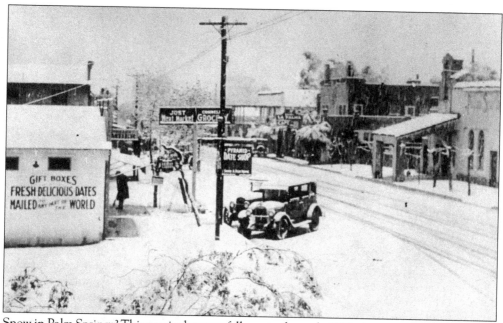

Snow in Palm Springs? This particular snowfall was in the early 1930s, but it was not the first and certainly not the last. However, it is a rare occasion and a cause for much excitement. It is sheer beauty to see the palms and cactus shining in a mantle of white. This photograph was taken on Palm Canyon Drive near the corner of Amado Road.

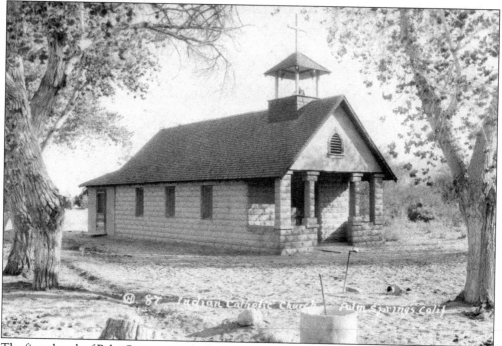

The first church of Palm Springs was the little Catholic Mission Church. Originally, it was known as St. Florian's Chapel, named for Fr. Florian Hahn, director of the St. Boniface Indian School in Banning. A larger, newer, and more modern church replaced the original chapel on Calle El Segundo. The name was eventually changed to Our Lady of Guadalupe.

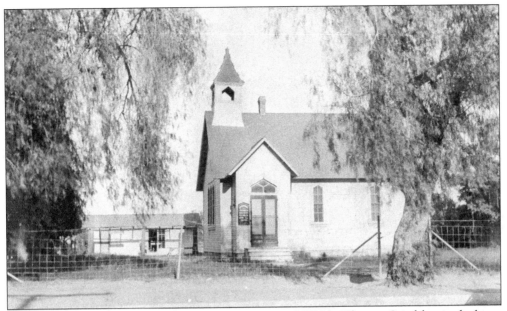

The first Community Church was built sometime around 1890 by Thomas Critchlow in the heart of town as a loving memorial to his wife. This church stood on what is now the corner of Palm Canyon Drive and Andreas Road. It was the only Protestant church in town.

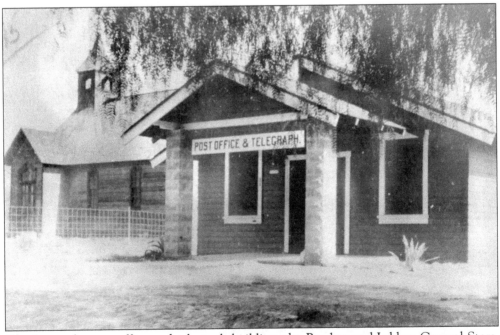

Starting as the post office and telegraph building, the Bartlett and Lykken General Store, eventually Carl Lykken's store, was the center of local activity. With no postal delivery, everyone met at the post office. Thus there was never any difficulty in meeting new people or catching up on the latest local news.

Built in 1895, the first school was located on Amado Road between Palm Canyon Drive and Indian Avenue. At one time, it was necessary to advertise for a teacher with at least three children so that there would be enough students to justify having a school. First through eighth grades were taught here. Those in high school had to go all of the way to Banning.

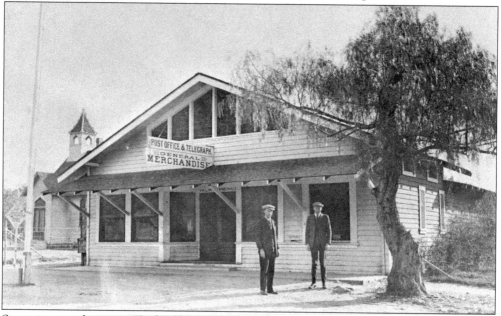

Store owner and manager Carl Lykken (right) discusses town topics with a friend in this picture. The Palm Springs Department Store carried hardware, mercantile items, and groceries. It also contained the post office and the town's first telephone. Although many times remodeled, the department store, under different ownership, occupies the same spot today. The adjacent white clapboard building with the bell tower was the original Palm Springs Community Church.

In the early 1920s, Dr. J. J. Kocher built Sunshine Court in the 300 block of North Palm Canyon Drive. This was a popular spot for golfers to stay because it backed up to the O'Donnell Golf Club. When the city incorporated in 1938, its first offices were housed in one of the cottages facing Palm Canyon Drive. It was recently razed for construction of the Amado Center.

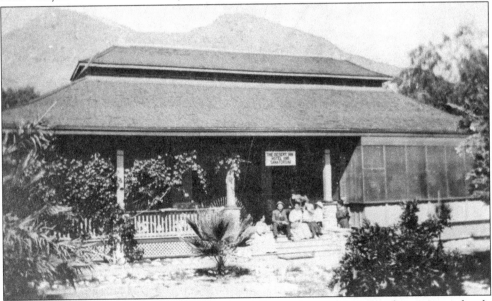

The sign announces "The Desert Inn Hotel and Sanatorium." This is another picture of early comers to the desert drawn by the healing properties of the sun and hot springs. The Desert Inn was a major landmark of the early village and was located where the Desert Fashion Plaza stands today.

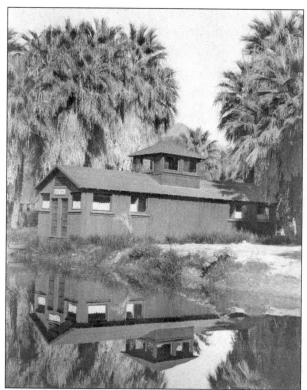

The second Bath House, built in 1914 in the same location as the first, was on the corner of Indian Canyon Drive and Tahquitz Canyon Way. For almost 10 decades, the hot, curative, mineral waters have been beneficial to Palm Springs visitors and locals. Today standing in that same spot is the luxurious Spa Hotel.

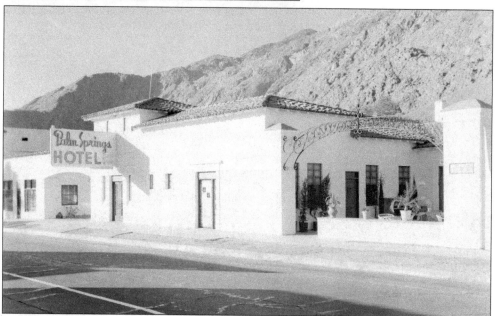

In 1921, the Foldesy family purchased the Ramona Hotel and renamed it the Palm Springs Hotel. It was in the 200 block of North Palm Canyon Drive. They successfully operated their famous resort for 57 years. This hotel and neighboring shops were razed in 1984 to make way for a new, large hotel. Once standing in this block were a famous nightclub, the Chi Chi, and Zaddie Bunker's original garage.

South of the Desert Inn and also on the west side of the street was the Oasis Hotel, which was built by Pearl McCallum McManus and designed by architect Lloyd Wright, son of architect Frank Lloyd Wright in 1923. On the grounds of the Oasis was also the McCallum family's original adobe home. The Oasis tower is still visible today and is a Palm Springs Class One historical site.

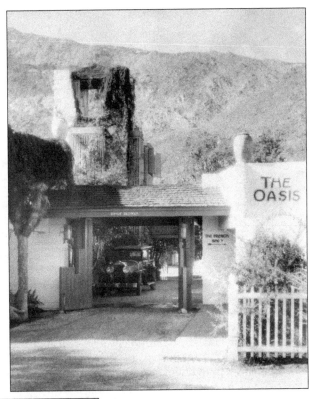

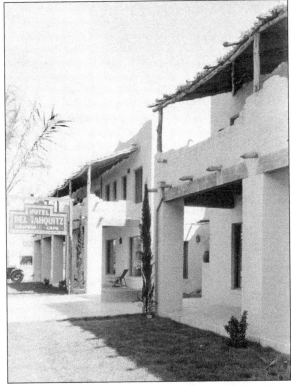

The Del Tahquitz Hotel was on the southeast corner of Palm Canyon Drive and Baristo Road, and was owned by Thomas and Wilberta Lipps. This was one of the larger hotels in town. It was popular during World War II with servicemen stationed in Palm Springs as "Ma" Lipps, as she was fondly known, was an excellent cook and hostess.

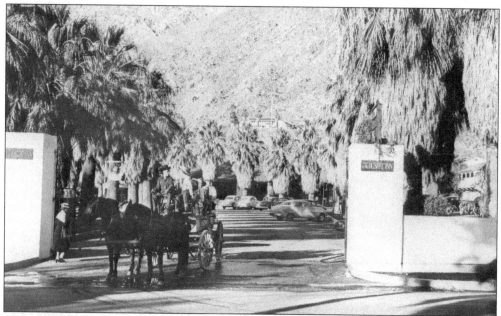

In the late 1920s and early 1930s, Palm Springs was discovered as a fashionable winter playground. Nellie Coffman built the beautiful new Desert Inn main building on the grounds of her "Desert Inn" hotel. This elegant spot, located in the center of the village, was the hub of the town's social life. Stagecoaches and hay wagons carrying eager tourists to chuck wagon feasts in the desert were a common sight. Horses and bicycles almost outnumbered cars.

Located next to the Wintergarden was the La Hacienda Hotel. Both of these hotels were demolished to make way for office buildings and shops. They were adjacent to the Village Green, the present-day Village Green Heritage Center. Many buildings of this era adopted the graceful Spanish Colonial–style architecture.

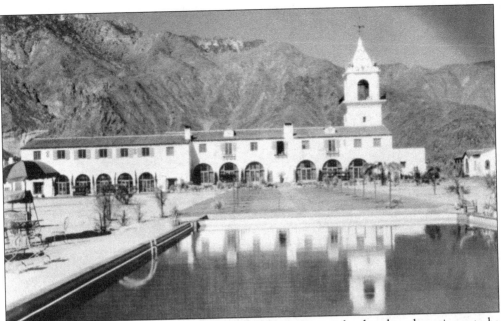

The El Mirador Hotel, built in 1928, was an early Palm Springs landmark and continues to be today. In the beginning, it was a five-star hotel attracting the rich and famous. However, with the advent of World War II, the buildings were taken over for use as a hospital. Although it has retained its famous tower from the hotel days, it has become the trauma center Desert Regional Medical Center.

In 1951, the El Mirador Hotel featured Eddie Howard and his band, and fans flocked to hear Eddie sing. The Desert Circus's Big Top Ball was often held at the El Mirador. Here participating in some of the Desert Circus festivities are actor Clint Walker (left) Mayor Frank Bogert (center), and Hollywood's famous gossip columnist Louella Parsons.

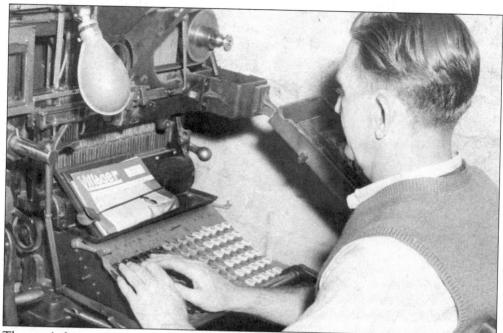

The area's first magazine, *The Villager*, was the forerunner of *Palm Springs Life Magazine*. It depicted life in the desert from the 1920s to the 1950s. George Wheeler was the publisher and editor. Advertised as a coffee table magazine, it gives readers a picture of what it was like when Palm Springs was truly a village.

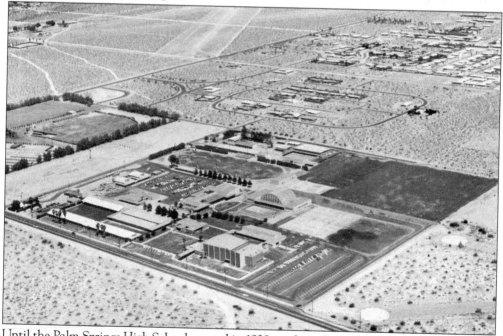

Until the Palm Springs High School opened in 1938, students finishing eighth grade were bused to Banning. This is not the original school, which had only 12 rooms, no gym, and no auditorium. In this photograph, the first airport is at the top center, Nellie Coffman Junior High is shown, and to the lower left is the Field Club, where all activities centered.

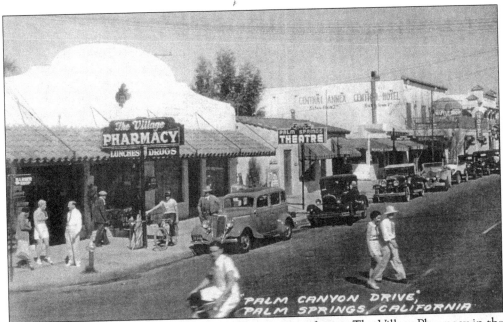

Palm Canyon Drive in the early 1930s was a busy center of town. The Village Pharmacy in the 200 block of North Palm Canyon Drive was a great gathering place because it included a lunch counter. This photograph also shows one of the first movie theaters, the Village Theatre, in the downtown area.

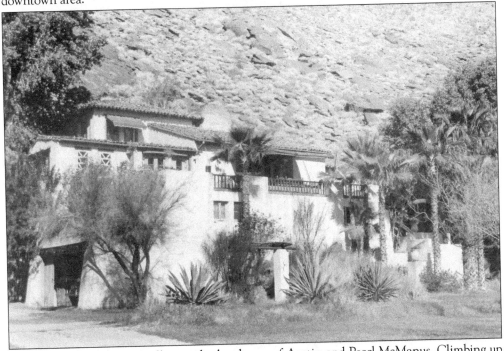

This pink Mediterranean villa was the last home of Austin and Pearl McManus. Climbing up the hillside next to her beloved Tennis Club, a spectacular view of the whole valley could be seen from the terraces. After Pearl's death, the new owners razed the mansion to build the Tennis Club Condominiums.

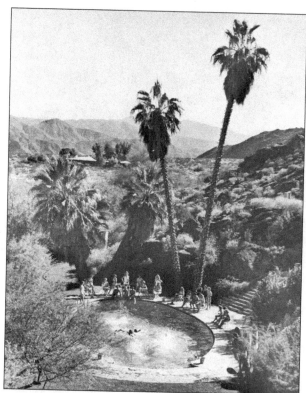

Next door to the pink mansion, Pearl McManus built the beautiful Palm Springs Tennis Club in the early 1930s. The oval-shaped pool shown in this photograph was famous for being the most photographed pool in the world. Architect Paul R. Williams designed the dining room, known as the Bougainvillea Room.

The Tahquitz irrigation canal ran through the grounds of the Tennis Club and provided another recreational activity—fishing—for its guests. The first mayor of Palm Springs, Philip Boyd, is seen here catching his limit of trout. His companion is Automobile Club official E. E. East. Note the rows of tennis courts in the background.

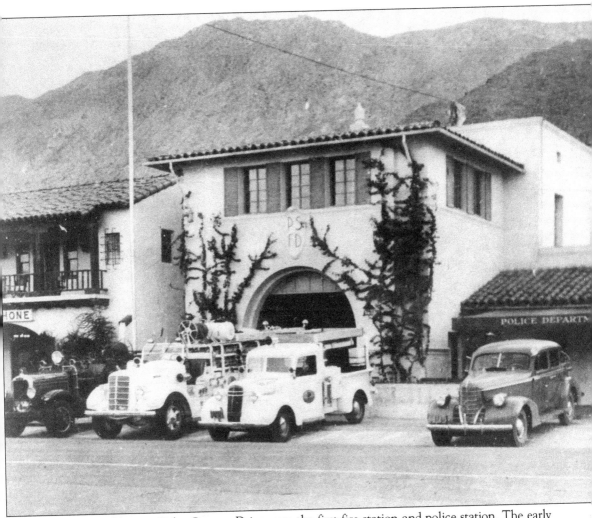

In one building on Palm Canyon Drive were the first fire station and police station. The early fire station had a chief, an assistant, and the loudest horn in creation. Over half the male population in town belonged to the volunteer fire department, and when that horn blew, they dropped everything and jumped on the truck as it flew by. A sign of the times is the size of the police station, located in the heart of downtown. Crime was not a big issue, and people even left their doors unlocked whether they were at home or running off to work. Built around 1939, the first Palm Springs Fire and Police Departments were located at 377 and 381 North Palm Canyon Drive, next door to the General Telephone office. Shown from left to right are the first motorized fire engine, a La France, a 1937 Mack, a 1939 Pickup (REO), and a 1939 Oldsmobile, the police department's only vehicle.

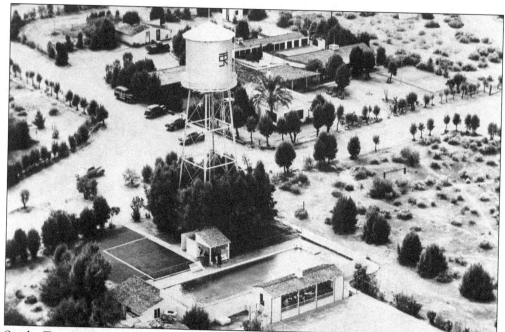

Smoke Tree Ranch was developed in 1925 by Mac Blankenhorn. This is an aerial view of the Smoke Tree Ranch pool, water tower, and octagonal kiva in 1941. The Smoke Tree Ranch brand can be seen on the water tower. The kiva served as an evening gathering place, had a stone-faced fireplace at one end, and was appointed with rustic chairs.

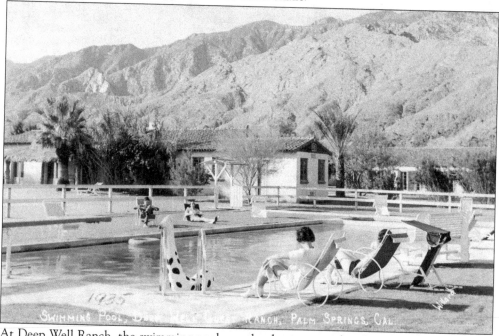

At Deep Well Ranch, the swimming pool was the daytime social gathering spot. Whether to swim or just lounge around the pool, guests had to acquire that desert tan to show off on their return home. This 1935 picture shows the Deep Well Ranch and cottages and the backdrop of the majestic mountains.

Five

BEGINNING OF TOURISM

Changes in the village transformed the former health retreat and agricultural area to the Palm Springs recognized today as a world-renowned tourist attraction. Not only did Hollywood stars and moguls discover the desert as a close and friendly getaway, but so did presidents, rulers of foreign countries, and the famous from all walks of life were greeted at the Palm Springs Airport.

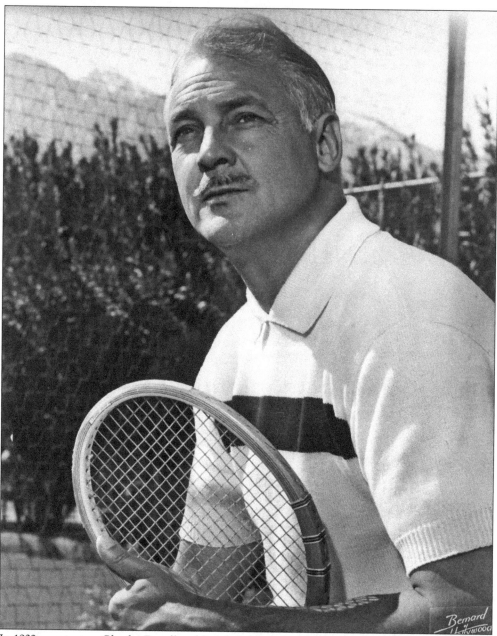

In 1932, movie stars Charles Farrell and Ralph Bellamy developed the now world-famous Racquet Club. Pictured here is Farrell, who had played opposite Janet Gaynor in the Academy Award –winning film *Seventh Heaven*. Soon Farrell bought out Bellamy and became the sole owner of the Racquet Club. Choosing to live here year-round, he became an active member of the community. Farrell Drive is named in his honor.

In 1938, when actress Virginia Valli married Charlie Farrell, she gave up a promising career to become his right-hand at the Palm Springs Racquet Club. Virginia ran the club for the three years that Charlie was serving in the U.S. Navy during World War II. The club never missed a beat and was even more popular in the postwar years.

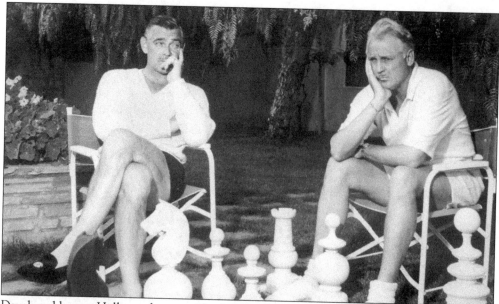

Developed by two Hollywood greats, Charlie Farrell and Ralph Bellamy, the Racquet Club has always been a favorite gathering spot for film folk. Seen here are Clark Gable (left) and Charlie Farrell (right) contemplating their next move in a game of lawn chess at the club. Charlie was the fifth mayor of Palm Springs and commuted to Hollywood to make the television series *My Little Margie* with Gale Storm. This made him one of the most famous and charismatic mayors in the country. (Photograph by Bernard of Hollywood.)

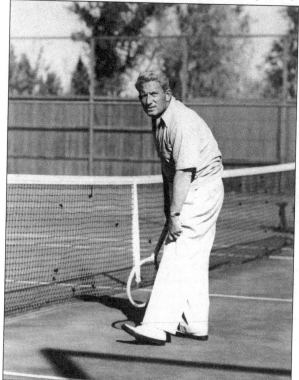

Spencer Tracy was a familiar figure at the Racquet Club on Indian Canyon Drive. In this picture, taken by Bill Anderson, he looks somewhat upset to have his game interrupted for someone wanting a picture. While attempts were made to let movie stars enjoy their privacy, they still had to endure an occasional publicity stunt.

In the 1930s, tennis was king in Palm Springs. Dinah Shore was very much into tennis at that time, and later she would sponsor the Dinah Shore Golf Tournament. Shown at the Racquet Club in the 1950s is Dinah with her husband, George Montgomery, who was not only a well-known actor but is probably more famous now for his artistic genius. His period furniture and bronzes are on display at the Palm Springs Art Museum. (Photograph by Bill Anderson.)

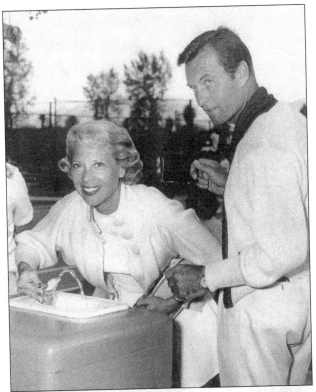

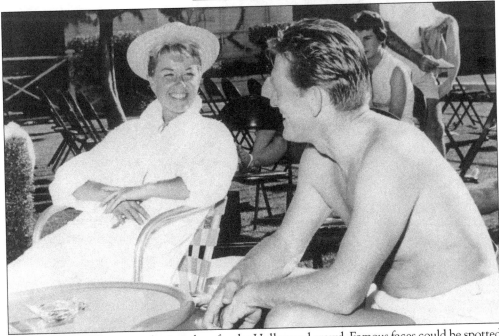

The Racquet Club was a gathering place for the Hollywood crowd. Famous faces could be spotted at any time, whether lounging around the pool, indulging in serious tennis, or relaxing at the bar or on the dance floor. Doris Day and Kirk Douglas are enjoying just such a moment poolside. (Photograph by Bill Anderson.)

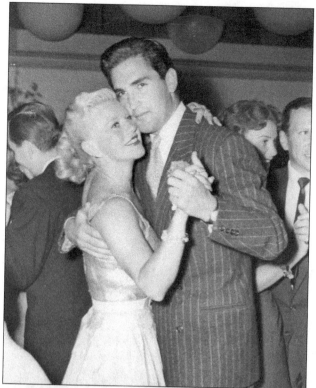

Ginger Rogers is showing off her dancing skills with her husband, Jacques Bergerac, on the dance floor of the Racquet Club. This famous and talented actress loved the desert and lived here until she passed away at her Thunderbird Country Club home in Rancho Mirage. Rogers was always a generous contributor to local charities. (Photograph by Bill Anderson.)

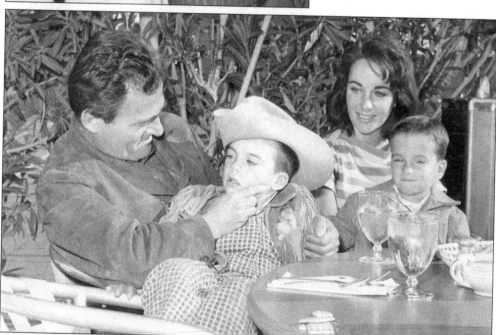

The late Mike Todd and his wife, Elizabeth Taylor, are seen breakfasting with her two boys poolside at the Racquet Club. Palm Springs was a favorite getaway for the couple in the 1940s and 1950s, and Mike Todd was popular with the local shopkeepers because he was always buying special gifts for Elizabeth. (Photograph by Bill Anderson.)

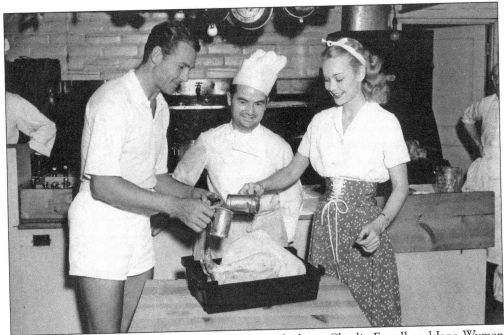

Thanksgiving is turkey time. This 1938 photograph shows Charlie Farrell and Jane Wyman assisting Racquet Club chef Rene in preparing the bird for this annual feast. While too many cooks can spoil the meal, when help comes in the form of a beautiful girl and the boss, Chef Rene welcomes it! (Photograph by Bill Anderson.)

Early in her career, Lucille Ball poses on the steps of the Palm Springs Tennis Club. She was a frequent visitor and resident of Palm Springs. She autographed this picture for Joan McManus, Tennis Club social director and sister-in-law of Pearl McManus. She was wise to wear a large hat in the desert sun.

In 1963, Red Skelton, a desert resident, focuses on two lovely queens, Marilu Ballagh, the rodeo queen, and his daughter Valentina, the desert circus queen. Both girls were students at Palm Springs High School. Although comedian Skelton is acting as a photographer in this picture, he also gained considerable recognition for his artistic renderings of clowns.

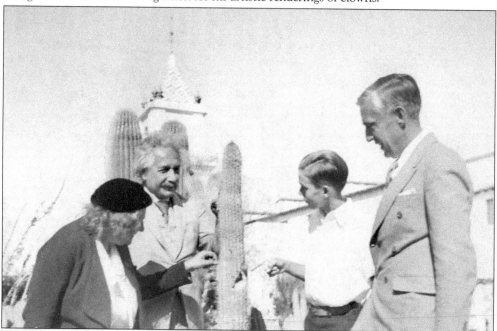

The threat of Hitler's storm clouds and storm troopers drove many to seek refuge in the United States. Among them were Professor Albert Einstein and his wife, Elsa. In this 1933 photograph, Professor Einstein and Elsa are shown admiring the El Mirador cactus garden with hotel manager Warren Pinney (far right), and Warren Pinney Jr.

In 1939, crooner Rudy Vallee (center) brought his band to Palm Springs. He chose the Racquet Club to broadcast his radio show. With club owners Ralph Bellamy (left) and Charlie Farrell (right), they admire a congratulatory cake sent by Al Wertheimer, owner of the Dunes Club, wishing them success.

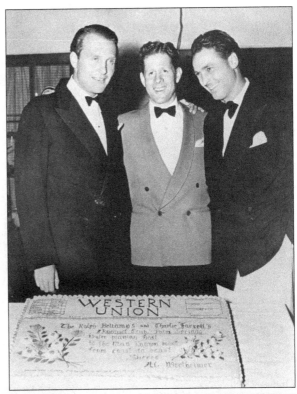

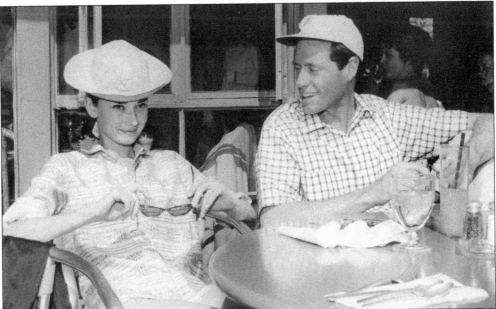

Without question, Audrey Hepburn was one of Hollywood's intrinsic stars. Apart from being a successful film star, Hepburn led an interesting and diverse life. After retirement from films, she worked with needy children in third-world countries. In this photograph of Hepburn in the early stages of her career, she and her husband, Mel Ferrer, are sitting poolside at the world famous Racquet Club. (Photograph by Bill Anderson.)

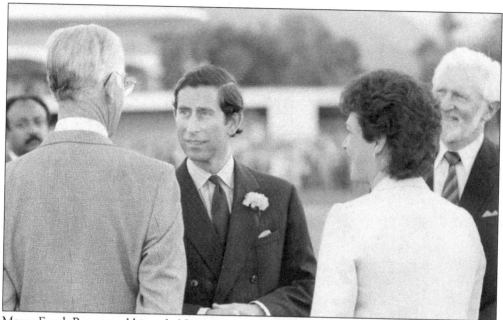

Mayor Frank Bogert and his wife, Negie, greet Britain's Prince Charles in the fall of 1986 upon his arrival at the Palm Springs Airport. During this weekend stay, the prince played his favorite game of polo and attended a fund-raising dinner for Operation Raleigh, a program he founded for young people. This was the second visit to the desert; he had visited in 1983 with his mother, Queen Elizabeth.

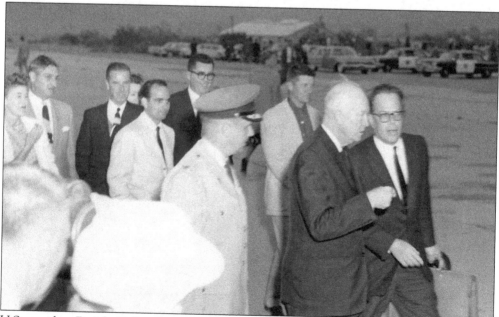

U.S. president Dwight D. Eisenhower's arrival in Palm Springs was one of the most exciting days in the history of the city. The Helms home at Smoke Tree Ranch became the Western White House. Greeting the president at the Palm Springs Airport is the 1954 City Council including, from left to right, Leonard Wolfe, John Woods, Ruth Hardy, George Beebe, Warren Slaughter, Ted McKinney, and California senator Thomas Kuchel.

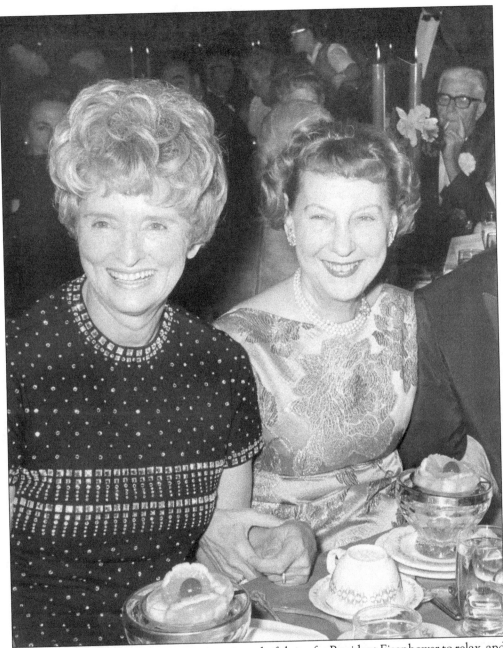

Coming to Palm Springs for vacation was a wonderful way for President Eisenhower to relax, and the best place to do this was on the golf course. So how did First Lady Mamie (right) spend her time? She was an avid bridge player and could always find a foursome. She also joined friends for luncheon. She is seen here dining with Dolores Hope (left).

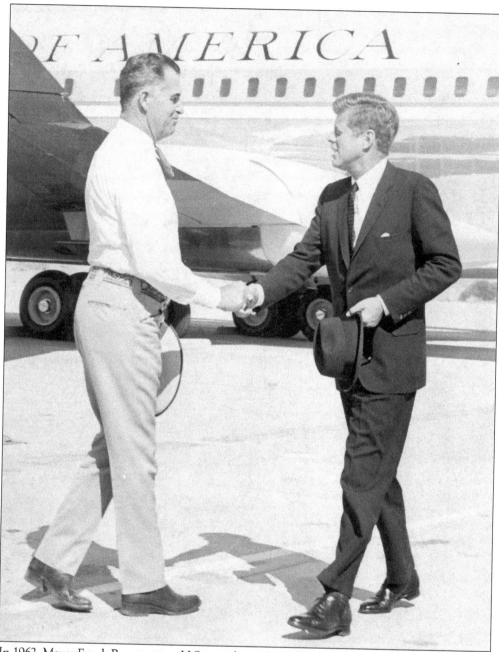

In 1962, Mayor Frank Bogert greets U.S. president John F. Kennedy on his first trip back to Palm Springs since becoming president. As a U.S. senator, Kennedy had been a frequent visitor at the Racquet Club. His sisters often vacationed here, as did his brother Bobby and his wife, Ethel. Most of the time, President Kennedy came to relax, but he would also use the opportunity to visit with former U.S. president Dwight D. Eisenhower.

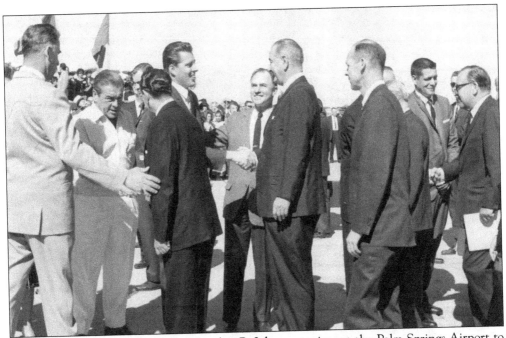

In this photograph, U.S. president Lyndon B. Johnson arrives at the Palm Springs Airport to meet with the president of Mexico, Lopez Mateos. On hand to greet the two presidents were (from left to right) Frank Bogert, Phil Regan, Lopez Mateos, and Congressman John Tunney (with his back to camera).

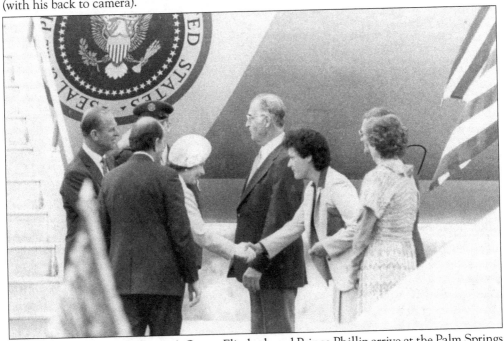

In this 1983 photograph, Britain's Queen Elizabeth and Prince Phillip arrive at the Palm Springs Airport as guests on Air Force One. They are en route to the home of the former U.S. ambassador to Great Britain Walter Annenberg, who resided in an estate in Rancho Mirage. Frank Bogert and his wife, Negie, greet them.

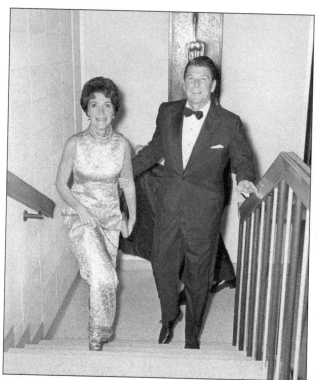

U.S. president Ronald Reagan and his wife, Nancy, were frequent visitors to Palm Springs. They were on hand for the dedication of the Eisenhower Medical Center. Prior to and during his presidency, the Reagans spent many New Year's Eves with Ambassador Walter Annenberg his wife, Lenore, at their Rancho Mirage estate. This 1966 photograph was taken of then-governor and Mrs. Reagan attending a reception at the old Desert Museum.

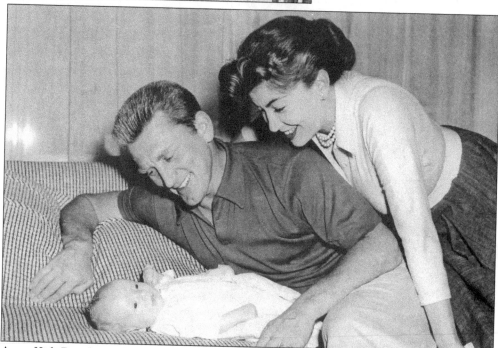

Actor Kirk Douglas and his wife, Anne, are admiring their new baby boy. The Douglases were desert residents for many years and were active participants in village affairs. Anne was another one of those glamorous tennis players, along with Dinah Shore and Mousie Powell, who frequented the courts of the Racquet Club.

The Christmas season is the time for family gatherings. This 1963 photograph shows Bing and Kathy Crosby with their children Nathaniel and Harry Jr. arriving for the holidays. Bing, along with Phil Harris, Bob Hope, Leonard Firestone, and Hoagy Carmichael, were among the first to buy homes on the fairways of the new Thunderbird Country Club opened in 1951.

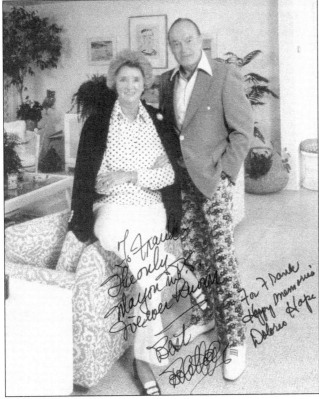

Dolores and Bob Hope were permanent residents of Palm Springs. This second home was a showplace high up on Southridge. The Hopes were most generous donors to local charities. They built the convent for the Sisters at Saint Theresa School. Dolores also donated the money for the chapel at the new Catholic high school, Saint Xavier Preparatory.

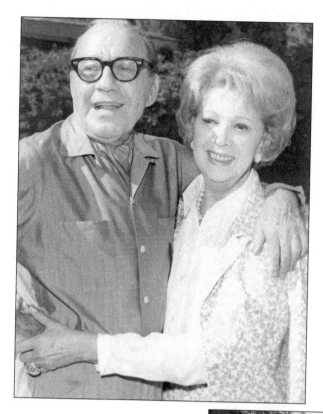

Jack Benny and his wife, Mary Livingston, were popular residents of Palm Springs. Often their radio shows were broadcast from the Plaza Theatre, the second theater opened and operated by Earle Strebe. The people of Palm Springs lined up for blocks to get free tickets to see the show.

William Powell will always be remembered as the master of sophisticated comedy. His famous *Thin Man* movies with Myrna Loy revolutionized film comedy in the 1930s. Bill Powell and his wife, actress Diana "Mousie" Lewis, purchased a lovely home in Palm Springs in 1941. Mousie started the Wednesday night mixed-doubles tennis at the Racquet Club. It became known as the "Mousie Burger."

Actress Rhonda Fleming poses for Bill Anderson with a copy of the November 30, 1953, *Desert Sun* newspaper. The headline refers to "Telemeter," which was a cable box for Palm Springs television. It was coin-operated and showed first-run movies and athletic events, as the headline reports. Telemeter was first introduced in Palm Springs.

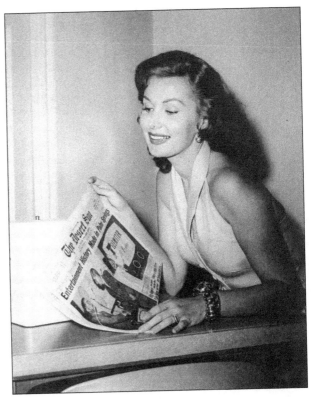

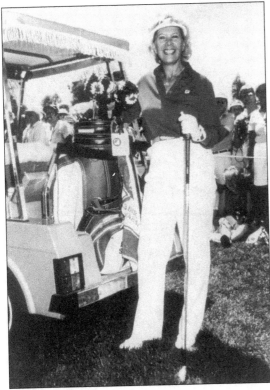

March was the month of the annual Nabisco Dinah Shore LPGA Championship. Shore made Palm Springs her home for many years. Before developing an interest in golf, she was an avid tennis player and could be seen almost daily on many Palm Springs courts. She was always generous in donating her time and talent to local charities such as the annual Policeman's Show.

Actor Bill Holden was a Palm Springs aficionado. From his home on Southridge, he enjoyed a panoramic view of the entire city. He and Ray Ryan were partners in the Mount Kenya Safari Club in East Africa. Bill Holden bequeathed his entire Asian and African collection to the Palm Springs Desert Museum. (Photograph by Bill Anderson.)

Clark Gable and his wife, Kay, were frequent visitors to Palm Springs. In 1942, Gable received the "Cowboy Oscar," which was awarded to stars and permanent residents for exceptional community service and fund-raising. The Gables were photographed here with Ray Ryan, the El Mirador Hotel owner at the time.

Foregoing his usual flamboyant finery, the late Lee Liberace (left) posed in desert Western wear with his brother George. Notice his famous trademark, the candelabra, on his boots. Lee Liberace enjoyed playing his piano and entertaining friends at his various homes around the desert. He died in 1987 in his favorite home located on Belardo Road in the Merito Vista Tract in Palm Springs.

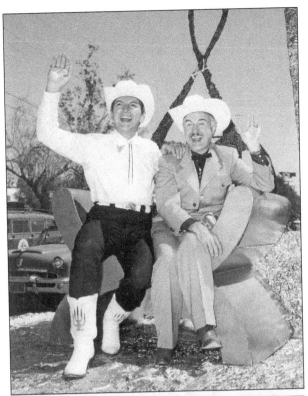

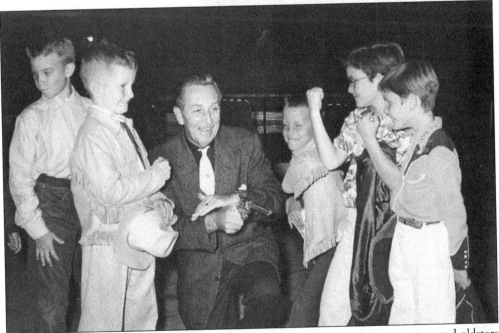

Walt Disney undoubtedly provided more wholesome entertainment to youngsters and oldsters than any producer in Hollywood. Disney, a longtime resident of Smoke Tree Ranch in Palm Springs, is pictured here with some of the young ranch hands, giving them lessons in the quick draw. Note the Smoke Tree Ranch emblem on Disney's tie.

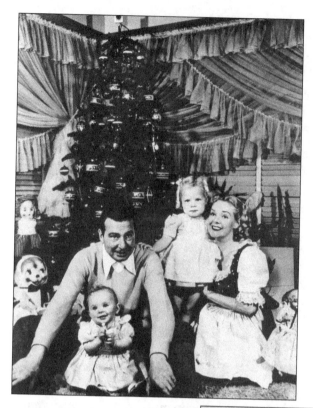

Phil Harris, his wife, Alice Faye, and his daughters Alice and Phyllis were busy celebrating Christmas in this photograph by *Palm Springs Life Magazine*. The Harris family was among the first to build at Thunderbird Country Club. Phil and Alice's popular CBS radio show was often broadcast over local station KCMJ, and many local residents recall attending these broadcasts. Daughters Alice and Phyllis attended the local St. Theresa School.

Actor Robert Taylor and horse could be seen on the many trails in and around Palm Springs. He is seen here leaving Smoke Tree Stables to join the Desert Riders for breakfast up in the canyon. The Desert Riders is the oldest riding group in Palm Springs and is still active today.

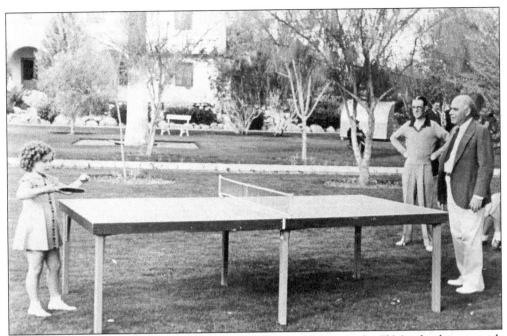

When New York's governor Herbert H. Lehman was vacationing at the El Mirador, his one wish was to meet Shirley Temple. Frank Bogert, El Mirador publicist, called the Temples, who visited the desert annually and who always stayed at the Desert Inn. Shirley joined the governor at the El Mirador for lunch and a game of Ping-Pong.

Margaret O'Brien was a charming child star. She is posing here on the diving board of the Ingleside Inn. The O'Briens were frequent guests at the Ingleside Inn before purchasing their own Palm Springs home. This inn was originally the private home of the Birge family and was built by local builder Alvah Hicks.

103

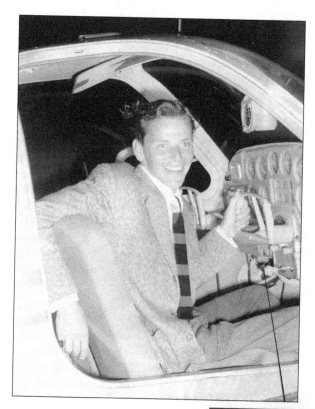

In his early career, Frank Sinatra is seen here at the Palm Springs Airport piloting his private airplane. As a loyal desert resident, he generously donated both time and money to his favorite charities. Desert Hospital and the Barbara Sinatra Children's Center at Eisenhower Medical Center both benefited from his gracious gifts.

This is a rare photograph of Marilyn Monroe caught by the official Racquet Club photographer, Bill Anderson. She is being entertained at the bar in the Bamboo Lounge, which is located within the Racquet Club. On the right is local resident and film star William Powell. It must have been a chilly evening for Monroe to be wearing a coat.

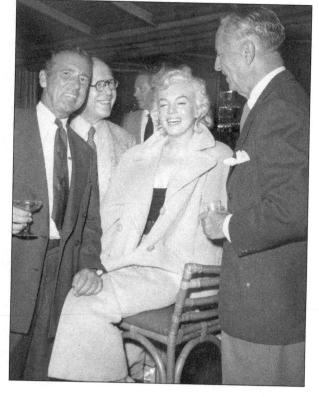

Six

ENTERTAINMENT

The first entertainment for the early settlers was simple; with no electricity, there was little nightlife. Picnics in the lovely Indian canyons were always popular, as were moonlight rides for barbecues out in the desert. As the village grew, so did restaurants. Starting in the early 1930s, Desert Circus was the highlight of the year. For one whole week, everyone went Western and joined in parades and other daily entertainment. Nightclubs with top entertainment flourished. Tennis matches and polo at the Field Club were great attractions. Enjoying the Western ambiance, Western Week opened up seasonal activities.

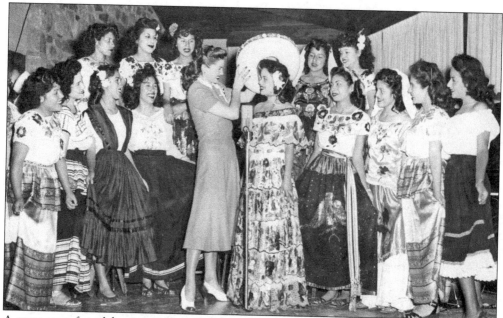

A great cause for celebration in the Mexican Colony Club was the girls vying to be the queen to preside over their Desert Circus float. Esther Williams is crowning the Mexican Colony queen in 1948. The annual Desert Circus Parade was a source of entertainment for the whole community, and the city's resident stars were quick to offer a helping hand because proceeds from the events went to local charities.

One of the earliest and only entertainments on Palm Canyon Drive was the bowling alley. It was also a social gathering spot. There were many spectators on the nights of the Men's League and the Women's League competitions. In this picture, screen legend Clark Gable and his wife, Kay (sporting a mink), were getting ready to bowl as Mayor Frank Bogert kept score.

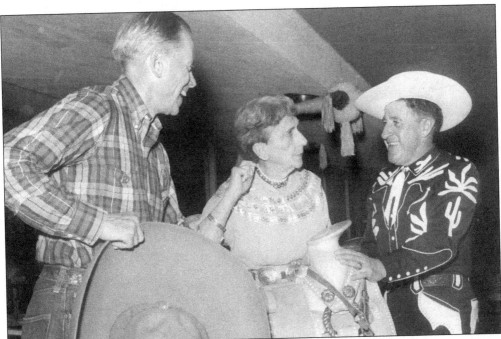

An avid horsewoman since the days she roamed the desert on her burro, Pearl McManus (center) was a charter member of the oldest Palm Springs organization, the Desert Riders. She is shown here admiring this beautiful saddle with fellow members Lloyd Laflin (left) and Mayor Ed McCoubrey.

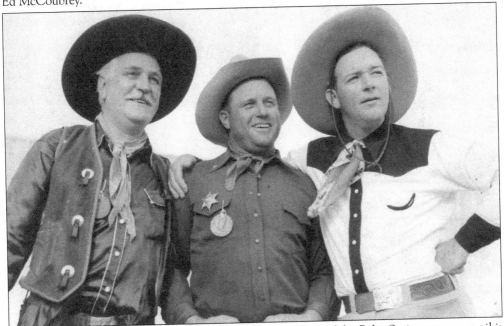

The Desert Circus started in 1934 and was the biggest event of the Palm Springs season until it was discontinued. From left to right, film star Frank Morgan (the wizard in the *Wizard of Oz*), Ranch Club owner Trav Rogers, and Western star Bill Gargan are seen wearing their badges to enforce the "rules" and help generate the fun of Desert Circus Week.

Charlton Heston and his son are decked out for a ride across the desert. Western attire was, for many years, the way to dress in Palm Springs, and on Fridays, even at work, everyone wore Western gear. Although the number of stables has dwindled, the best way to view the desert is from the many trails maintained by the Desert Riders, a local equestrian group.

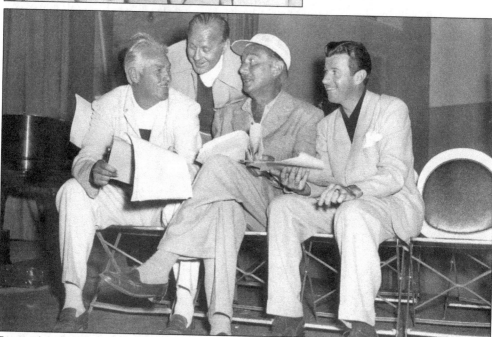

Pictured from left to right, Charlie Farrell, Jack Benny, Paul Lukas, and Dennis Day are going over the script for Jack Benny's radio show, which was broadcast from the Plaza Theatre. In the script *Murder at the Racquet Club*, many sleuths were called in to determine why a dead body was found lying by the pool. It was decided no murder had been committed. The sun had gone down, and the man froze to death.

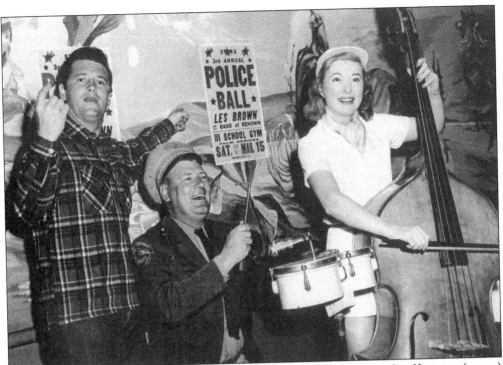

The annual Police Ball was a great event in the village. Chief of police Gus Kettman (center) charmed many of Hollywood's brightest stars to donate their talents to this outstanding show. Les Brown and his Band of Renown always played to a packed house. Helping Gus promote the third annual Police Ball are Gordon MacRae (left) and Greer Garson (right).

Little Bear led the annual Christmas parades during the 1930s and 1940s. She led all the local parades and taught most of the town's youngsters how to ride. Santa used to arrive by airplane; the stagecoach and Little Bear met him. The parade ended at Frances Stevens School, where all the children received stockings filled with candy. After Little Bear's death, her horse—carrying only her boots and saddle—led the Desert Circus Parade.

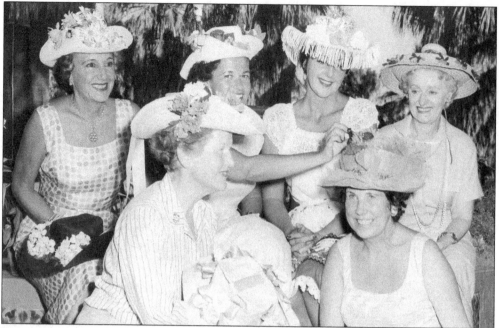

Reviving the Hat Parade luncheon after World War II was expected to draw a large crowd. Showing off their chapeaux are (from left to right, first row) Melba Bennett, originator of the "Palm Springs Hat," and Hildy Crawford; (second row) committee members Anita Haskell Jones, Mrs. Ray (Blake) Corliss, Wanda Alles, and Joan McManus. The affair took place in the Chi Chi Rainbow Room.

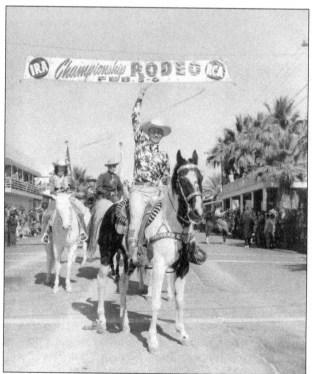

Monte Montana rode his horse onto the stage of the Palm Springs High School to put on a performance for the kids during Desert Circus week. One could always count on Monte to support the Western spirit of Palm Springs. No parade was complete without that talented cowboy.

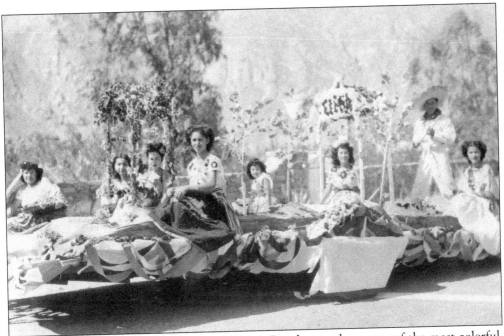

The Mexican Colony float in the Desert Circus Parade was always one of the most colorful. While the years change, many of the names are familiar. From left to right are Dora Martinez, Candy Reyes, Stella Prieto, Vera Prieto, Beverly Mendoza, Queen Helen Prieto, an unidentified musician, and Eleanor Mendoza.

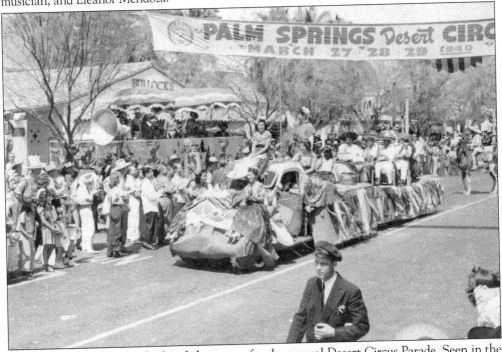

Everyone turned out and the lined the streets for the annual Desert Circus Parade. Seen in the background is the original Bullock's Department Store on the Desert Inn grounds. A good way to start the day was to enjoy the Lion's Club pancake breakfast prepared for hundreds.

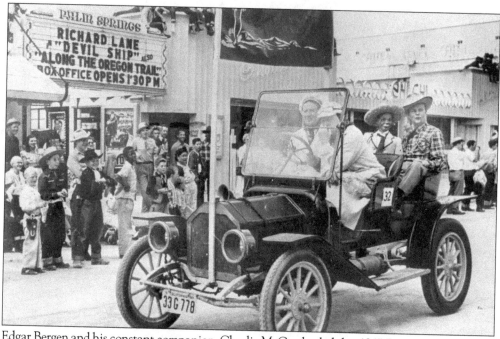

Edgar Bergen and his constant companion, Charlie McCarthy, led this 1947 Desert Circus Parade. This photograph was taken in front of the Palm Springs Theatre and famous Chi Chi nightclub. Following World War II, Bergen purchased a Southwestern-style home and grape ranch nestled in a date grove in the area of the College of the Desert in Palm Desert.

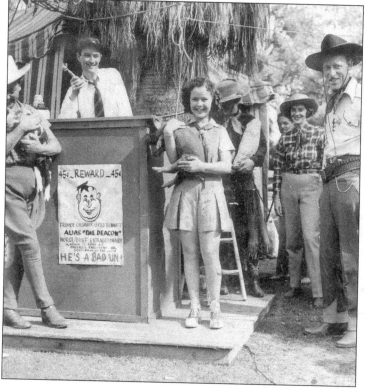

The lovely front lawn of the Desert Inn being in the heart of town was an ideal spot to hold "Kangaroo Court," another fun activity. Anyone not wearing Western attire would be hauled into court and fined or made to entertain. Shirley Temple is raffling off a pig to the delight of Leo Fields. All the money raised during Desert Circus went to desert charities.

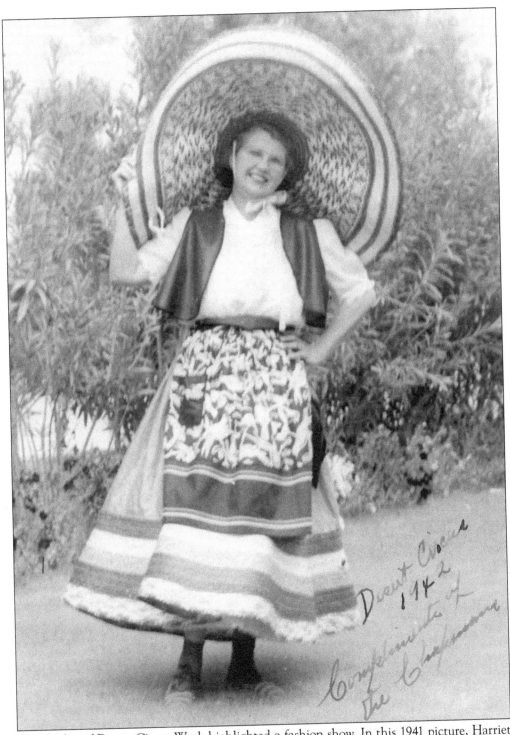

Wednesday of Desert Circus Week highlighted a fashion show. In this 1941 picture, Harriet Henderson is seen in a vivid Spanish costume. Harriet herself is barely visible as she bobbed gaily from beneath a six-foot-wide Mexican hat. Harriet, her husband, Charles, and son Joseph came to live in Palm Springs in 1923, and all were active in the community.

Here the Desert Circus deputies have hauled some great victims into Kangaroo Court, where Judge Leo Fields presides. Prisoners could earn their release by entertaining the audience. Partners Dean Martin and Jerry Lewis, with Leo in the background, were a crowd-pleaser. The Village Insanities and the Big Top Ball were part of the week's festivities.

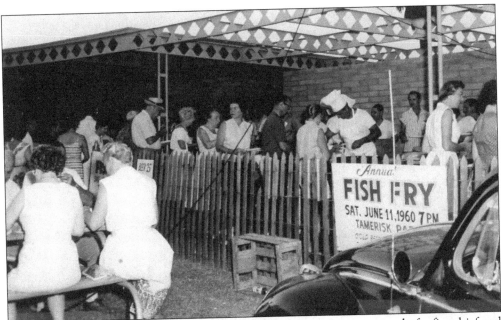

The Fireman's Fish Fry began in the 1920s, when the department consisted of a fire chief and local volunteers. A loud horn announced a fire, and as the truck headed down Palm Canyon Drive, volunteers would drop their work and hop aboard. The fish fry helped defray costs and was first held on the O'Donnell Golf Course. Just as popular today as then, it is held yearly at the Ruth Hardy Park.

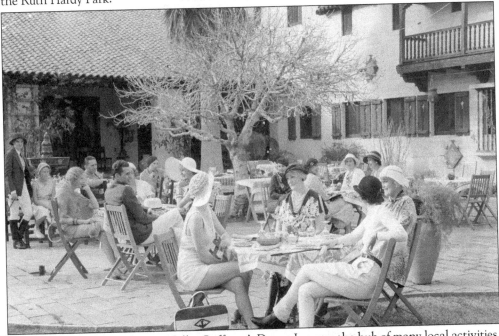

Located in the center of town, Nellie Coffman's Desert Inn was the hub of many local activities. Luncheon was served on the front patio or along the wide porch, where many a bridge game was played. It is interesting to note the diversity in women's clothing, and only one woman appears not to be wearing a hat.

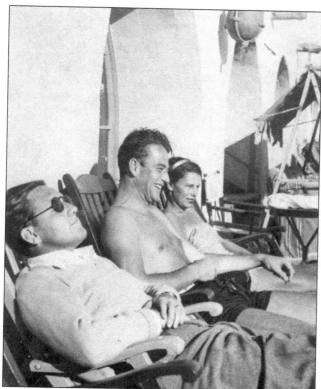

Sunbathing was a popular activity. If one did not already have one, it was a must to get a desert tan. Of course, sunscreen had not yet been invented. Lounging around the El Mirador Hotel pool are John Wayne (center) and his wife, who are already tan. Their companion Spencer Tracy seems more cautious.

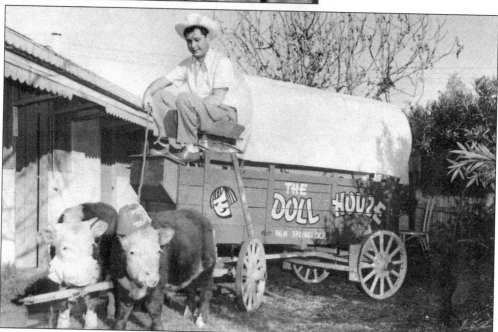

The annual opening of the Doll House was an occasion not to be missed. The Doll House was the one of the most popular spots for locals to meet. Shown in this photograph are owner George Strebe and his tiny team of miniature Herefords. George and Ethel Strebe's restaurant was noted for great entertainment and superb dining, especially "Those Potatoes."

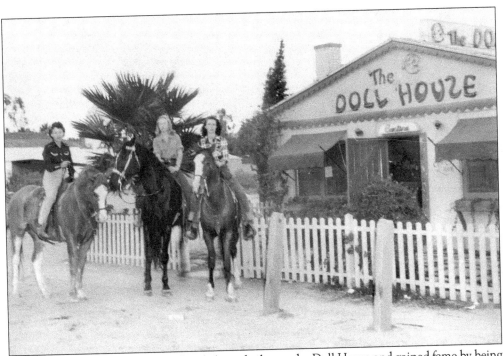

The Guadalajara Trio entertained nightly in the bar at the Doll House and gained fame by being featured on the Jack Benny Radio Show that was broadcast live from the Plaza Theatre. In this photograph, three local girls pose on horses in front of the Doll House.

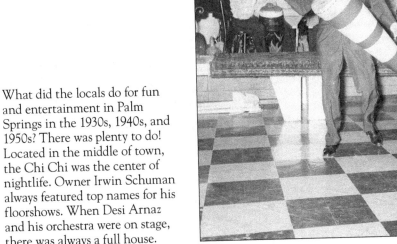

What did the locals do for fun and entertainment in Palm Springs in the 1930s, 1940s, and 1950s? There was plenty to do! Located in the middle of town, the Chi Chi was the center of nightlife. Owner Irwin Schuman always featured top names for his floorshows. When Desi Arnaz and his orchestra were on stage, there was always a full house.

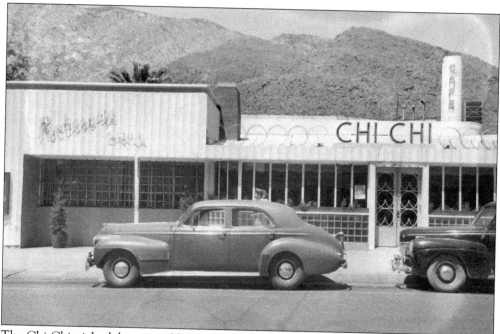

The Chi Chi nightclub was world famous and attracted the top performers from all over the world, including singers, dancers, strippers, comedians, magic acts, and vaudeville performers. In 1961, Irwin Schuman sold the Chi Chi, and it was never the same. It eventually closed in 1969. Schuman went on to build the Riviera Hotel, which has become a world-class resort.

Another popular dining spot was Ruby's Dunes. Amiable host Irwin "Ruby" Rubenstein was noted not only for his excellent cuisine but also for his lovely songstress wife, Connie Barlow. Frequently seen at the Dunes was Ruby's buddy Frank Sinatra. The first operation in this historic building was Harry's Palm Springs Café, the first Italian American restaurant in Palm Springs, owned and operated by pioneer Harry Mutascio.

One building that has outlived the others is the present-day Lyon's English Grille. The building that stands at the division of South and East Palm Canyon Drives has quite a history. It has been the Black Tent, specializing in dates and juices, and also served as a noncommissioned officer's club during World War II. Years later, it was the Palm House. It is nostalgic to dine at Lyon's for all the memories it evokes.

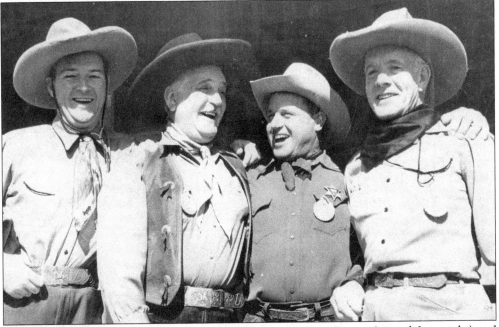

Frank Bogert snapped this picture of Ranch Club owner Trav Rogers (second from right) and his good buddies from Hollywood, from left to right, actors William Gargan, Frank Morgan, and Lewis Stone, who all participated in the many breakfast rides out into the desert. They were always ready for impromptu entertaining such as singing, storytelling, and jokes. Bing Crosby was a frequent diner at the ranch as well.

In 1926, Thomas O'Donnell built a home on the mountainside above downtown Palm Springs. He built a nine-hole golf course on the flat land below his home for his friends to enjoy long before golf became "the desert sport." Today it is a private golf club and the site of the annual Palm Springs Historical Society Pioneer Picnic.

The first lawn bowling green in Palm Springs was implemented in 1939 at the Tennis Club. Lawn bowling manifested as a throwback to times of "old money" graciousness and charm. "A little charm will go a long way," recalls Tony Burke in his book *Palm Springs: Why I Love You*, lamenting the passing of the old guard. It remains a popular sport to this day at Smoke Tree Ranch.

Early entertainment for the guests of Pearl McManus's Tennis Club was fishing for trout in the Tahquitz irrigation flume, swimming in the beautiful oval-shaped pool, and playing tennis. This picture of the early days of the Tennis Club shows the Tahquitz flume flowing through the hotel grounds.

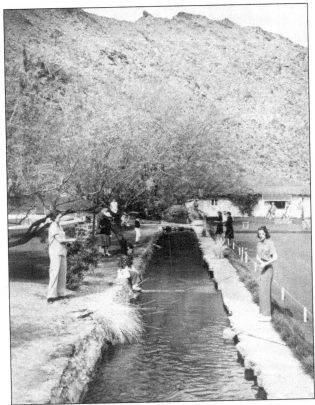

Bicycling was a popular sport in Palm Springs. Here early enthusiasts of the sport are seen in the Indian canyons. Rentals were available on Palm Canyon Drive, where cyclists and horses were almost as numerous as cars. Today bicycle lanes make it a safe pastime, and gasoline prices make it an affordable way to travel around the city.

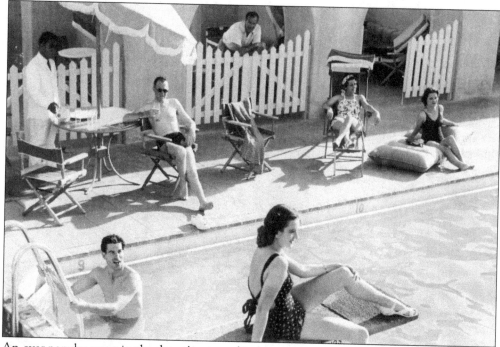

An ever-popular sport in the desert's warm climate was swimming. Whether for doing laps or just sunbathing, the hotel pools were a gathering spot. This group was enjoying themselves at the El Mirador Hotel. In the early days, there were no pools for the locals, so Tahquitz Creek was a great spot to cool off.

Splashing, kicking, and enjoying the pool at the El Mirador Hotel is the winter adventure of these lucky little guests. The sunlight and water mix together to provide a wonderful day in Palm Springs in the 1930s. The café and bar at the hotel add to the enjoyment for both the children and their parents.

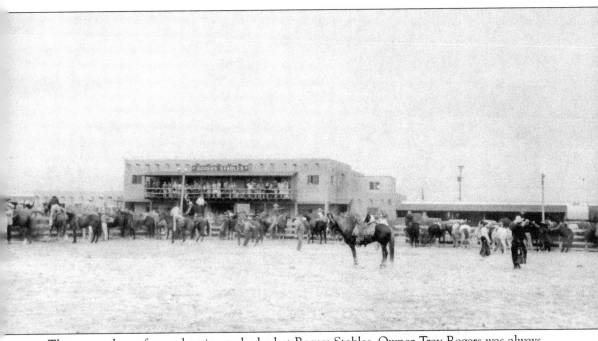

There was always fun and action to be had at Rogers Stables. Owner Trav Rogers was always on hand to see that his guests had a good time. During the day, the ranch provided horses for breakfast rides and trail riding, but at night it really came alive. Meals included spareribs, huge steaks, and baked beans, and the bar was always open. Frank Bogert recalls regular dancing and square and round dancing, with both he and Rogers calling the dances. In later years, the name "stables" was struck for the more dignified Ranch Club. There was the lower floor bar called the Mink and Manure Club, with horse stalls on both sides, and a long table was provided for the ladies to throw their mink coats and proceed to the bar. The Ranch Club sadly ended its reign and is now condominiums.

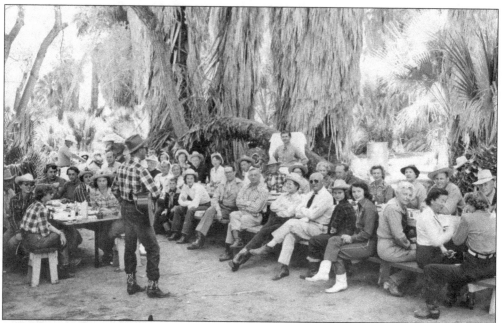

The Desert Riders was the first organization in Palm Springs. Every Tuesday, members and guests saddled up for a long ride. Once a month, they gathered for a catered lunch. This group has gathered in Andreas Canyon for a lunch catered by Jack Boyer and with entertainment by outstanding Western singer Johnny Boyle. This is still the custom today, which includes a monthly dinner gathering.

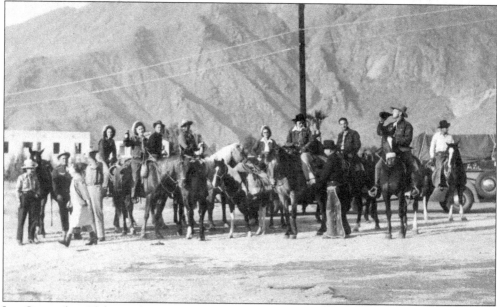

Los Compadres Club was the second riding club in the desert. Founded in the late 1930s, it was for the working class of riders who were only able to ride on weekends, with their own chuck wagon with Sunday breakfasts and moonlight steak rides. After building their clubhouse, the riders built their deep pit barbecue. It is now a tradition, and the barbecue has music and dancing to entertain almost 1,000 people a year.

Another popular sport before World War II was skeet shooting. Carl Bradshaw's skeet shooting range was on East Ramon Road past the Palm Springs High School. As it was located far from any activities and surrounded by undeveloped desert, it posed no danger to anyone but maybe a daring jackrabbit.

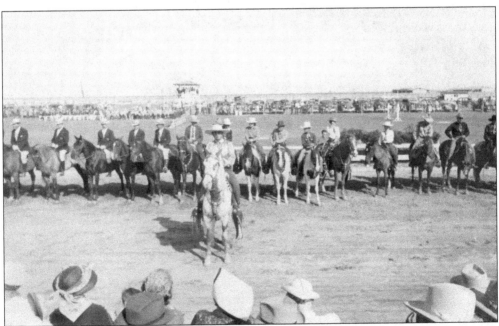

An exciting yearly event was the rodeo sponsored by the Mounted Police. It started with a parade down Palm Canyon Drive, which ended at the Field Club on Ramon Road. Crowds gathered in the stands to watch the skills of cowboys who came from all over to compete for prize money. The Mounted Police donated their time to rescue lost hikers on the adjacent mountains.

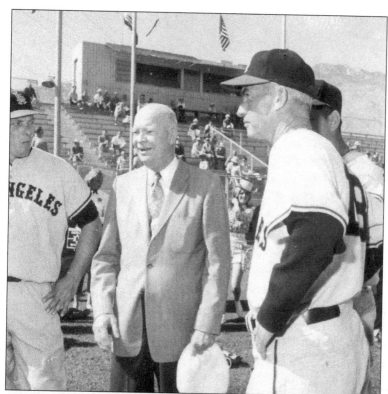

U.S. president Dwight D. Eisenhower visits the Los Angeles Angels baseball team during their annual spring training camp, which was held in Palm Springs at the Angel Stadium. Pictured from left to right are Angels pitcher Bo Bolinski, President Eisenhower, and Angels manager Bill Rigney. Everyone loved having the Angels in town.

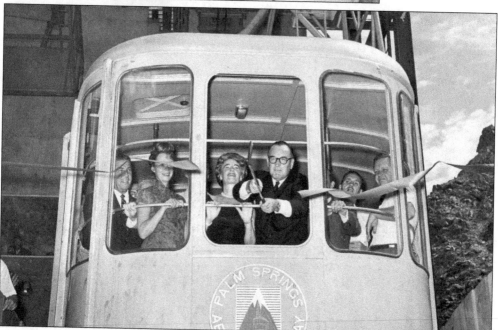

The Palm Springs Aerial Tramway has remained a must-do tourist attraction. It rises from the floor of the desert practically straight up to the top of Mount San Jacinto. The long-awaited opening of the tram took place on September 14, 1963, with California governor Pat Brown and his wife, Bernice, on hand to christen the first official tram ride with a bottle of champagne.

The brainchild of pioneer Earl Coffman, a tramway from the floor of the desert to the top of the mountain finally came into fruition. The Palm Springs Aerial Tramway always attracts the rich and famous. Pictured in the 1970s are Prince Rainier and Princess Grace of Monaco and their three children with a friend.

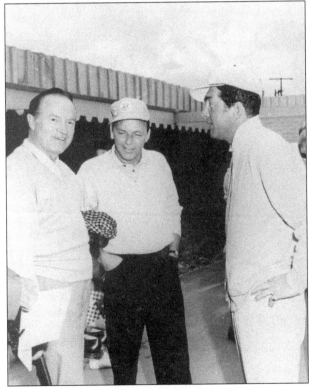

The Bob Hope Desert Golf Classic brought the best male golfers to the desert courses. Golf stars, singers, and politicians came to compete in this annual event. In this 1963 shot, Frank Sinatra (center) and Dean Martin (right) join Bob Hope. These men and many more participating celebrities helped to attract crowds of enthusiastic golf speculators to the desert. Sinatra, Hope, and Martin were longtime Palm Springs residents.

Visit us at
arcadiapublishing.com

CPSIA information can be obtained
at www.ICGtesting.com
Printed in the USA
LVHW100222100919
630428LV00029B/1776/P